EALING

THROUGH TIME

Jonathan Oates *&* Paul Lang

AMBERLEY PUBLISHING

This book is dedicated to our children

First published 2013

Amberley Publishing
The Hill, Stroud, Gloucestershire, GL5 4EP
www.amberley-books.com

Copyright © Jonathan Oates & Paul Lang, 2013

The right of Jonathan Oates & Paul Lang to be identified as
the Authors of this work has been asserted in accordance
with the Copyrights, Designs and Patents Act 1988.

ISBN 978 1 4456 1712 1 (print)
ISBN 978 1 4456 1721 3 (ebook)

British Library Cataloguing in Publication Data.
A catalogue record for this book is available from the
British Library.

Typesetting by Amberley Publishing.
Printed in Great Britain.

Introduction

This book concerns Ealing proper, namely the old parish or the modern postcode zones of W5 and W13. It does not deal with the post-1920s borough of Ealing (which included Greenford, Hanwell, Northolt and Perivale) nor the post-1965 London Borough of Ealing (which also included the former boroughs of Acton and Southall). This book is based on ninety Ealing postcards, mostly produced in the first half of the twentieth century, and contrasted against ninety photographs of the same views (traffic allowing) taken in 2013, with commentary.

There have been several books previously published showing Ealing in old postcards, and they customarily begin with remarks about Ealing's history. However, little is usually said about the pictures themselves as a whole. Modern readers (are there any who are not?) will be aware that postcards are usually only on sale in tourist destinations, National Trust properties and museums, and certainly do not feature views of local streets and buildings. Anyone doubting this can check at the local newsagents.

Yet readers of this book, who will doubtless have scanned the pictures in it before reading the introduction, will be aware that formerly a great many postcards were undoubtedly produced. Those appearing here are the tip of the iceberg. Between around 1900 and 1920, the postcard industry in Britain and elsewhere was significant. There were very many photographers who produced postcards, as well as studio photographs of individuals and groups. Most towns would have at least one, but photographers from elsewhere also got in on the act, including firms from overseas and they specialised in wealthier districts. Ealing as (self-proclaimed) Queen of the Suburbs in the 1900s was thus a prime candidate for their attentions.

They existed because of the simple economic laws of supply and demand. Photography in London had been in existence, albeit from a tiny base, since 1839. As decades passed, the process became cheaper and so commercially viable for photographers to go into mass production. But we must consider demand; universal elementary education was compulsory from 1880, and thus a literate market of consumers came into being. They wanted to communicate with one another, especially when friends and family resided miles from each other (in 1911 only a minority of Ealing residents had been born in Ealing). Yet very few people had a personal telephone at home; possibly one in twenty in Ealing. Letter writing was one option, of course, but postage costs were expensive. In 1901, only a halfpenny stamp was required on a postcard and so presented a cheaper alternative (some readers might like to think of them as the equivalents of emails or

'texts'). We should also remember that postmen made seven local deliveries on weekdays, and so a postcard sent on Friday morning in Ealing might reach its recipient in Hornsey, for example, later that day. Postcards represented the cheapest and most efficient mode of communication for the vast majority of the population who lacked a telephone.

In case this sounds like a victory for the forces of the 'dismal science', we should have another pause for thought. Although postcards had been in existence in Britain since 1890, they had not been popular because they were merely a blank card on one side and the other side was for the message and address. From around 1900, photographers had been putting views on the hitherto blank side, thus creating a mini work of art. Common subjects were prominent buildings, such as town halls, churches and schools. Open spaces were a popular subject, as were bridges, rivers and other geographical features. Streets were also photographed. These included main thoroughfares such as scenes taken along the Uxbridge Road, but also included other streets as well. Transport often featured in these pictures (chiefly trams and horse-drawn vehicles), and people also appeared therein. For the modern viewer these cards give snapshots of life in the past and so are a valuable form of social and local history. However, as with any historical source, they have their limitations. Photographers were businessmen not (explicitly) social commentators. Realising that few people want to buy scenes of local deprivation, they did not venture into Ealing's less affluent districts, such as Steven's Town in West Ealing, or those small terraced streets located where the shopping centre now stands. Pictures were black and white, sepia or hand coloured.

The postcard industry's golden age passed around 1920, when postage costs were doubled to a whole penny and telephone usage increased, albeit slowly. Furthermore, changes in the camera industry meant that more people owned cameras and used them because they were cheaper and easier to use. Yet postcards of Ealing were still being produced in the 1920s and 1930s. It was only in the 1960s that the industry declined into what it is now.

Many photographers operated in Ealing. The principal one, from whom many of these cards were taken, was Wakefields, who also produced studio photographs and were employed by the council to take official pictures. Wakefields was founded by Frank Wakefield in the 1870s. By the 1900s, when they were producing postcards as well, they were based in the Mall and on the High Street. Although Frank died in 1929, his sons carried on with the business, though George died in 1941. By this time they only had studios on the Mall and remained in business there until 1953, when the firm ceased to exist. Another local photographer was Wyndhams, based in Brentford and Acton in the years prior to the First World War. There were other publishers of Ealing postcards, too, including one firm in Tonbridge Wells, Photocrom, and two firms from Germany, one from Saxony (before 1914, of course).

The book has been organised by geographical districts – central Ealing (Ealing Broadway, Ealing Green, Walpole Park), west Ealing, south Ealing, north Ealing (the latter two are chiefly residential, but also include schools and churches), and Ealing Common and its environs, which is to the east of central Ealing. Inevitably central Ealing – that stretch along the Uxbridge Road and its offshoots along the Green to the south and Haven Green to the north – takes the lion's share of the photographs. This is the best known part of Ealing, whether for residents, shoppers or workers, and postcard manufacturers concentrated upon it.

There is at present no narrative history of Ealing in print. Books by Peter Hounsell, such as *Ealing and Hanwell Past* (1991) and *The Ealing Book* (2005), are recommended, as is the relevant chapter in the seventh volume of the *Victoria County History of Middlesex*. There are also older histories of Ealing and two volumes by Charles Jones (1830–1913), Ealing's surveyor and architect from 1863 to 1913, who is often quoted in this book. A controversial figure in his own time, nevertheless, future generations owe much to him. He was responsible for laying the foundations of Ealing as a modern town by creating its basic infrastructure, as well as designing several prominent buildings and securing open spaces to be used as parks. Nikolaus Pevsner's *Buildings of England (London: North West)* is also an invaluable source of architectural history, and John Gauss's typescript concerning local streets is also useful. Contemporary directories and maps provided important information too.

Many of the buildings from decades past as depicted in the postcards still survive, sometimes with different purposes, but the main changes are the increased congestion, both of people and of transport. In some cases, there has been radical change, as when a building has been destroyed and replaced with another, though these views are in the minority. Given the growth of population from about 33,000 people in 1901, change is inevitable.

This book should appeal to all who are interested in Ealing and its history. Although some of the postcards will be familiar to some, many are rare and have not been published in book form before.

Thanks go to Charles Jobson for helping with the purchase of the postcards used here.

Central Ealing

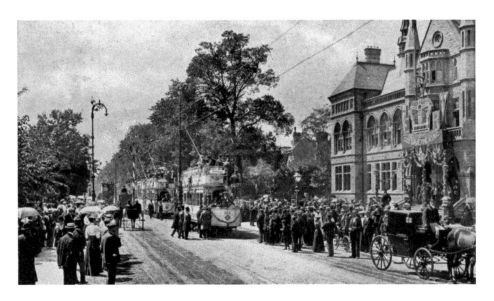

Charter Day Celebrations
This first postcard shows an important day in Ealing's history. This was the inauguration of the trams along the Uxbridge Road from Southall to Shepherd's Bush on 10 July 1901. Many saw this as good news for it gave working men cheap transport, but others (such as Charles Jones) saw it as a threat to the middle-class status of the town. This day also saw the reading of a royal charter, which led to Ealing becoming the first incorporated borough in Middlesex. Although the reintroduction of trams was envisaged in the early twenty-first century, it was defeated. The building on the right of both pictures is the town hall. For a fuller discussion see page 18.

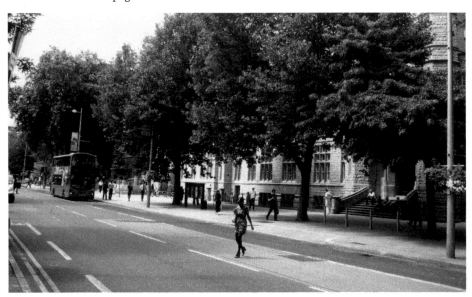

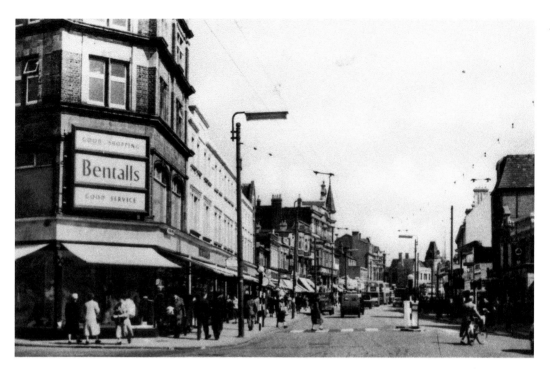

Ealing Broadway

This view eastwards along Ealing Broadway dates from the 1950s. The shop on the left was Bentalls, a department store that began its existence as Eldred Sayers' drapery store, founded in 1837. In 1950, it was taken over by Bentalls, a Kingston business, but relocated to the Ealing Broadway shopping centre in 1984. Until a few years ago, the corner shop was a branch of HMV, the music store. The building is now part of a small shopping arcade, The Arcadia.

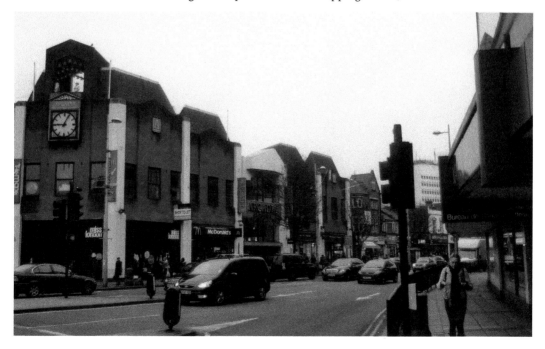

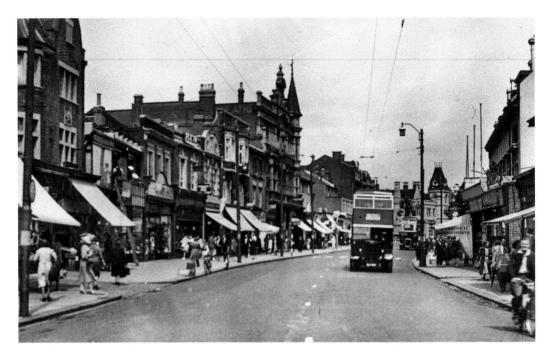

Ealing Broadway

Another view of the Broadway from the east from a different angle. The shops to the left of the postcard (9–19 Ealing Broadway), in the early 1950s, included Wicks' tobacconists, Arnold's milliners, Roseanne's ladies' outfitters, Zeeta's restaurant and a commissioner for oaths. They have been replaced by a bakery, a shoe shop, a newsagent, a photograph shop and a fast-food establishment.

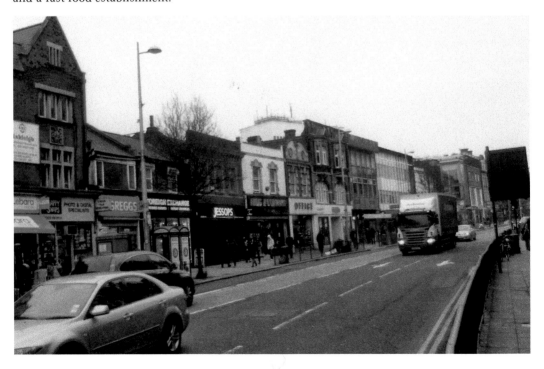

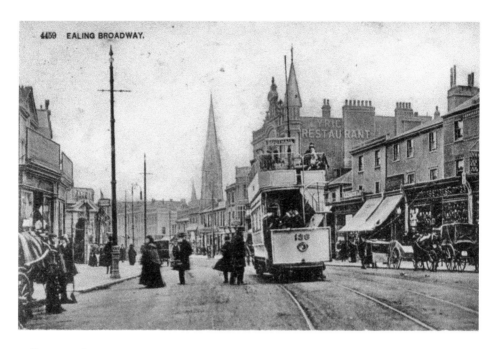

4459 EALING BROADWAY.

Ealing Broadway

This busy Edwardian scene is of the northern side of the eastern part of Ealing Broadway, showing both shops and the Ealing Theatre, though the building is labelled Lyric Restaurant. This is because the theatre on that site was called the Lyric from 1881, but in 1900 it was rebuilt by George Pargeter. The original name was retained for the restaurant. Transport was in an era of transition, with the electric trams, dating from 1901, and horse-drawn vehicles, too. The theatre later became a cinema (The Cinamatograph, later the Palladium), but was demolished in 1958 and a branch of WHSmith's now stands on the site. Now, as then, it was a busy thoroughfare with pedestrians and public transport. Christ Church's spire can be seen in the centre of each picture.

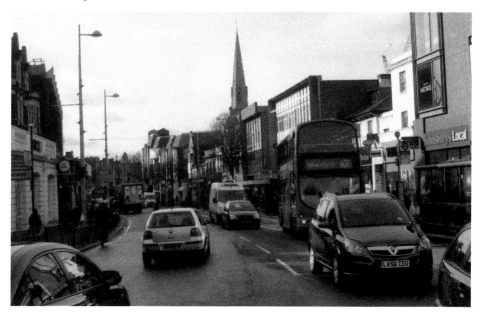

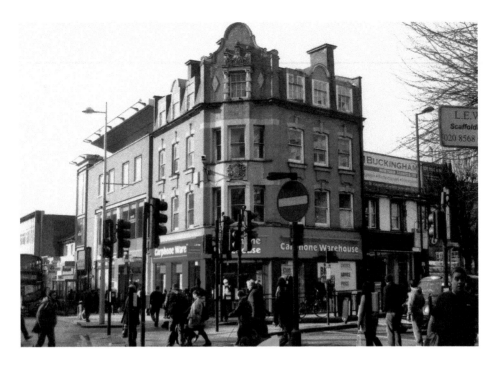

Corner of the Broadway

Another view of the Broadway, taken further eastwards. The shop at the corner from 1895 to 1972 was Foster Brothers, the complete outfitters (a men's clothing store); this site now houses a mobile telephone shop. Many of the buildings, except for the more prominent church, have been replaced by other buildings. In 1905, the shops between the theatre and Foster's were Frank Harman's gentlemen's outfitters, Bruce Wallace's oil and colour shop, Cridland & Sons, a butcher's, Buree's drug store and Smith's wine merchants. They now include a mini-supermarket and a coffee shop.

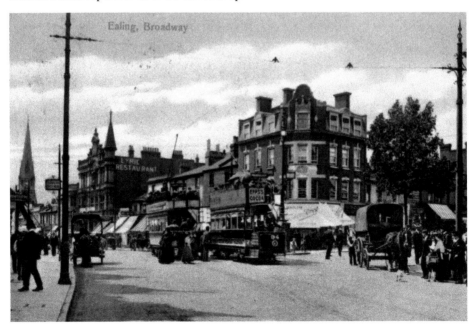

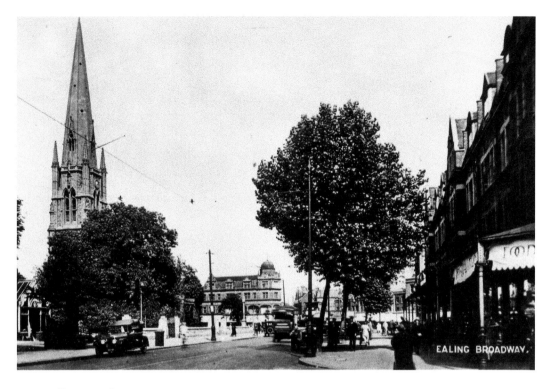

Ealing Broadway

The Broadway, looking eastwards, with another view of Christ Church, and with Sayers department store in the background. The latter was established in 1837 but is long gone and has been replaced by a small shopping centre, built in 1985/86, initially called The Waterglades but renamed The Arcadia Centre in 1997.

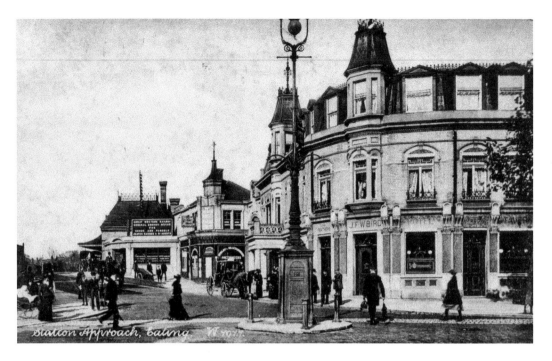

Station Approach

John Frederick William Bird was licensee of the Feathers Hotel from around 1899–1909, which helps date this postcard. A pub had stood on the same site since at least the early eighteenth century, but the one seen here had been rebuilt as recently as 1891 by Edwin Stephens. It provided accommodation and meals as well as liquid refreshment. After being renamed The Town House in the 1990s, and then lying derelict for some time, the building reopened in 2013 as a Metrobank. In 1904, the shops between the railway station and the pub included John Bird's tobacconists and a branch of Kasner's coal merchants and railway agents.

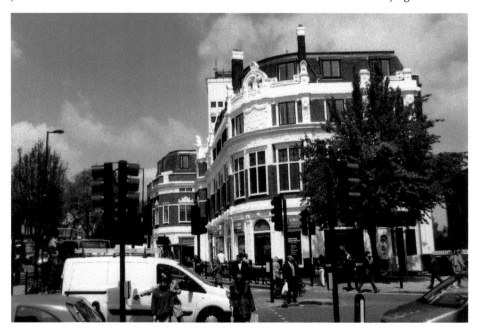

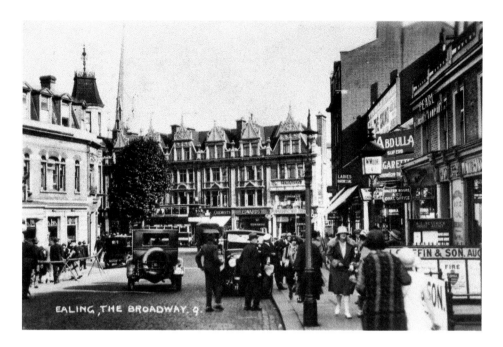

EALING, THE BROADWAY. 9.

Ealing Broadway

Another busy scene showing part of Ealing Broadway, taken from the north and looking south. Both fashion and transport indicate that this is the 1920s, though since the pub seems to be the same building as in the previous picture, it cannot post-date 1928 for it was again rebuilt in 1928/29. The shops in the background were built in 1902 on the site of the former parish almshouse – rebuilt in Church Gardens in 1902/03 and designed by William Pite, who also designed All Saints' church (*see page 89*). In 1905 they included a branch of Edward's, a furniture store (which also had branches in Bayswater and Kensington). Although the building now houses a shoe shop, the name Edward's remains on its side. The church spire in both pictures was that of the Wesleyan church in Windsor Road, designed by Charles Jones, but became redundant in 1972, and is now the Polish parish church of Ealing (*see page 38*).

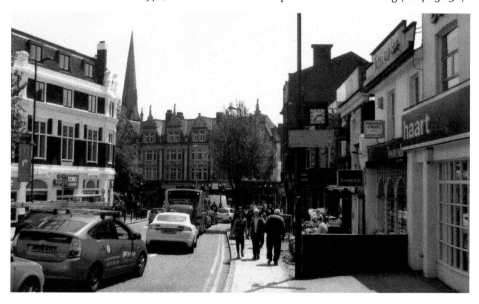

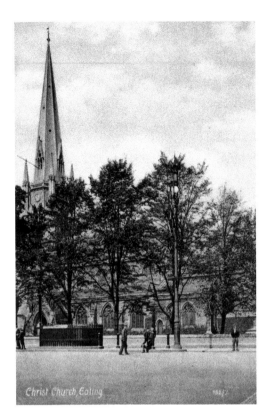

Christ Church

Christ Church was Ealing's second Anglican church, designed in 1851/52 by that frenetic architect of churches, George Gilbert Scott. It merged with St Saviours' church (*see page 37*) in 1952 to become Christ the Saviour. Jones wrote of the church, 'Sir Gilbert Scott produced many larger, and, maybe, more pretentious works, but none more beautiful, whether it be in the exquisite detail of its interior, or the pure yet simple outline of the exterior design'. The church suffered from the Second World War and the result is that the pinnacles at the base of the spire are now no more. Perhaps it is worth noticing the structure standing in front of the church, too. These were public conveniences, erected in the first decade of the twentieth century, but removed by 1987, as had most of those in the borough. Market stalls now stand in the foreground, selling foodstuffs.

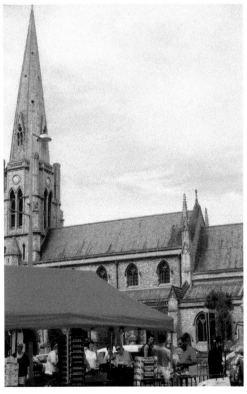

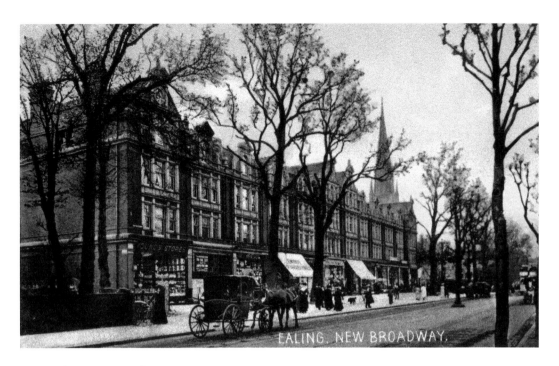

Ealing New Broadway

The New Broadway was one of Ealing's main shopping thoroughfares. Young's Stores, on the far left of the card, sold china and glassware from this site from the 1880s until at least 1940. Other shops there in the 1900s were Thomas Day's, a corn chandler, Squire's piano shop, an estate agent's, a fruiterer and a bakery, amongst others. In 2013, none of these remained and in their stead were four restaurants, a charity shop, a stationer's, a bank and a bathroom shop.

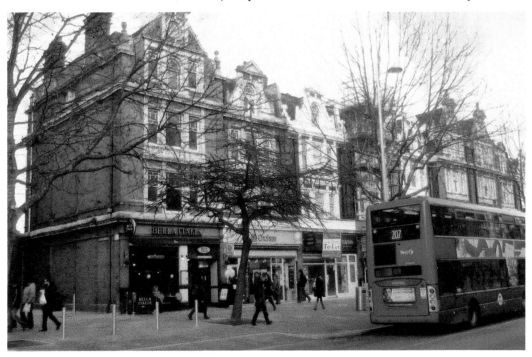

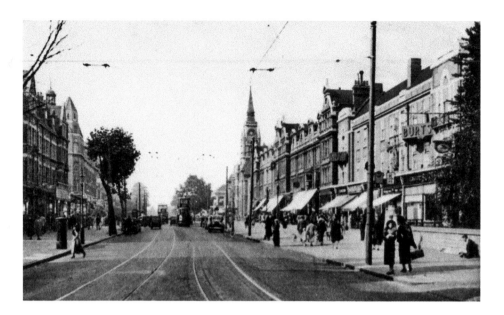

New Broadway

Another view of the New Broadway, focusing on the north side of the street from the wall of the Christ the Saviour church to the town hall's spire. It has often been said, both then and now, that the latter spire is that of a church. But just as now, most rate payers (council tax payers) did not treat it with suitable reverence. Also note the (possibly legless) beggar to the right of the postcard; such sights are not uncommon now, but the inclusion on the photographer's part indicates a keen social observer, or more likely a man who wanted to get his job done and couldn't wait for him to leave. Most of the shops that were here in 1905 remained, but a new addition by the 1920s was William Ottways', makers of precision optical instruments, used in peace and war, and a branch of the Prudential Assurance Company was also located there by this time. In more recent years, the shops nearest the church wall have been demolished and are now replaced by showrooms for the Dickens Yard development currently being built behind the shops, to the right of the picture.

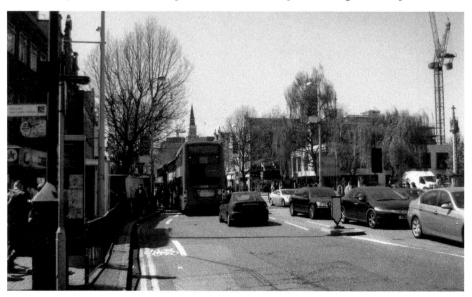

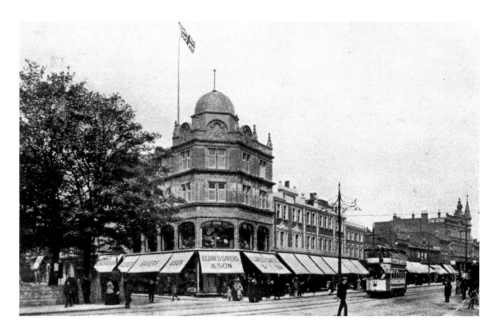

Sayers' Corner

Eldred Sayers' store was founded in 1837 and expanded over the following decades. Shown here in its Edwardian heyday, described as being a 'Silk mercers. Pressmen, Costumiers, House Furnishers, Carpets, Bedding and Bedstead, Warehousemen, Linen Factors and General Fancy Drapers'. It occupied Nos 2–7 the Broadway on the corner of the Uxbridge Road in 'a most prominent and conspicuous position in the Broadway'. It was apparently patronised by families who spent much of their time in India or the colonies (and the store operated a mail order scheme for such customers, too). In 1950, it was taken over by Bentalls, who moved into the new shopping centre in 1984, when the building here was demolished and the present Arcadia Centre was built.

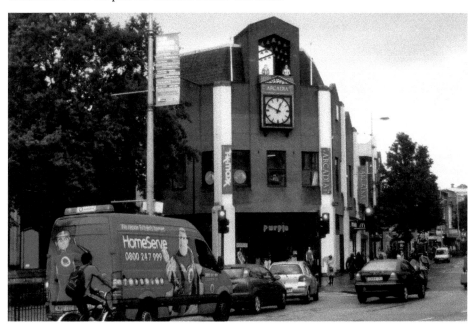

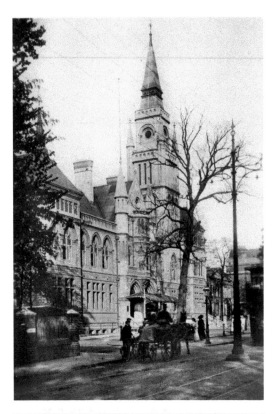

Ealing Town Hall

Ealing's town hall was designed by Charles Jones in 1887 to provide accommodation for an ever-increasing army of local public servants, after the initial council offices (*see page 85*) further down the road proved inadequate. There was local opposition because of the increased expense. This new building was opened by the Prince of Wales in 1888 and once housed the public library (1888–1901). Over the years it was expanded eastwards (1930), in the same gothic style, by Prynne and Johnstone, leading to an additional grand entrance and interior staircase. Since the 1980s, most of the council's staff are employed in Perceval House, which was never intended for the purpose, and is just to the left of this picture.

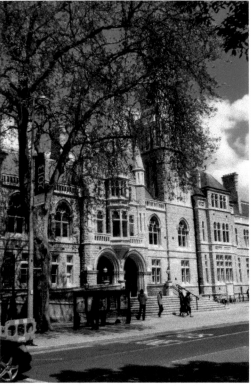

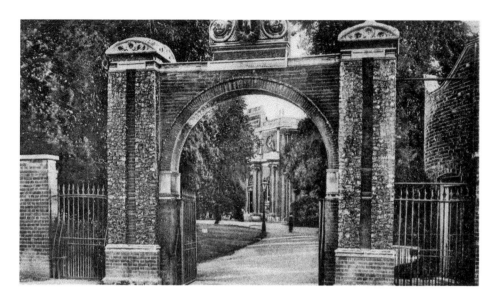

Archway, Pitzhanger Manor

The following pages are devoted to what is, without doubt, one of the more attractive parts of Ealing. This view has changed little in essence over the decades. It dates from the time of John Soane's ownership, when he greatly modified and beautified his country house in Ealing. This archway (Grade I listed) marked the main entrance for family and guests, beyond which we can glimpse the colonnaded eastern exterior of Pitzhanger Manor (also Grade I listed). Initially the Manor House's main entrance was where it is now, i.e. at the eastern side abutting the Green. Although the exterior of the central block of the Manor House is unchanged, the northern wing to its right was demolished and a new (and very plain) wing was added in 1940 to accommodate the growth of the library, which the building housed from 1902–84. In 1905, the library had 11,269 lending books and 1,618 in its reference stock. Opening hours were 10 a.m.–8.30 p.m., except for Thursdays, Sundays, public holidays and the first two weeks of August. It now hosts art exhibitions.

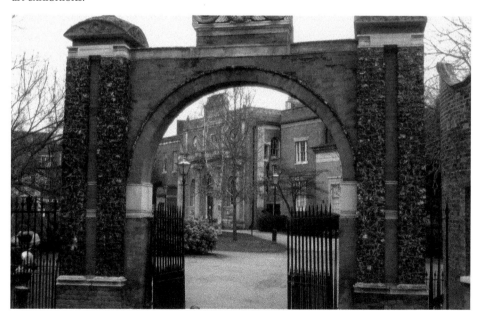

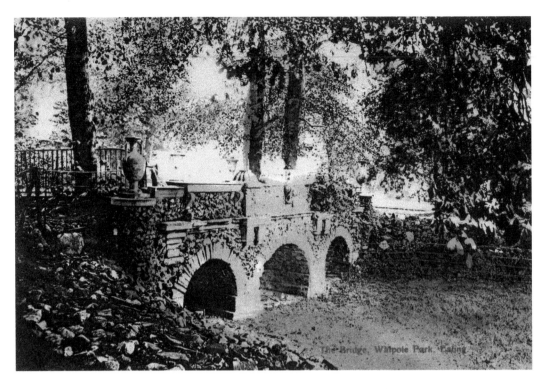

The Bridge, Walpole Park

Another Soanesque feature that has remained remarkably unaltered is this rustic bridge (Grade II listed), again embellished by Soane in the first decade of the nineteenth century, to highlight its imagined antiquity. Soane (1753–1837) was one of the foremost architects of his age, and was knighted shortly before his death. He owned the property in the first decade of the nineteenth century.

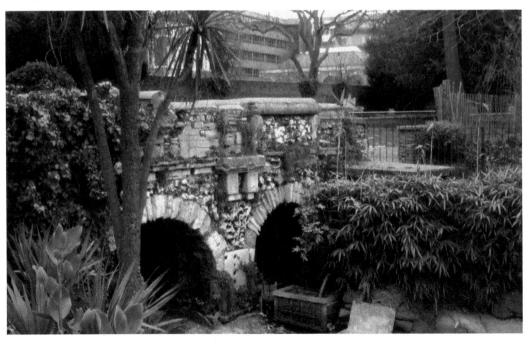

Walpole Park West Entrance

This view is taken from the west gate of the park, the one nearest to Lammas Park. Walpole Park never looked so peaceful as in this postcard, and that was how the council initially envisaged it when it was opened to the public in 1901. No playing games was allowed – in contrast with Lammas Park (*see page 42*) – and young children and the elderly were given priority.

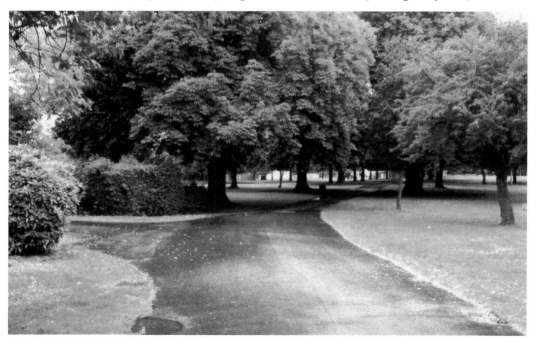

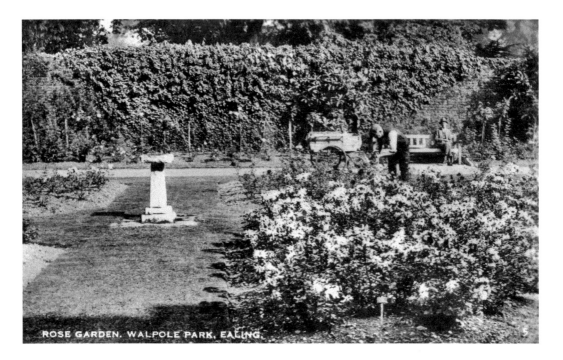

ROSE GARDEN. WALPOLE PARK. EALING.

Rose Garden, Walpole Park

This rose garden was initially a kitchen garden for the Manor House when it was in private hands. It allegedly provided fruit and vegetables for Charles Jones at this time, too. After the house and grounds were bought by the council, this southern portion of the grounds was in great danger of being built upon. One suggestion was that the almshouses, which were on Uxbridge Road and were demolished in 1900, be rebuilt there. Another was that a school be put on the site. Residents were up in arms, one writing in 1910, that he had 'often enjoyed the beauty and restfulness of this fine walled garden, which must be almost, if not quite, unique as a secluded and sheltered adjunct to a public park'. Both schemes were happily defeated and this spot remains, usually, as tranquil as ever.

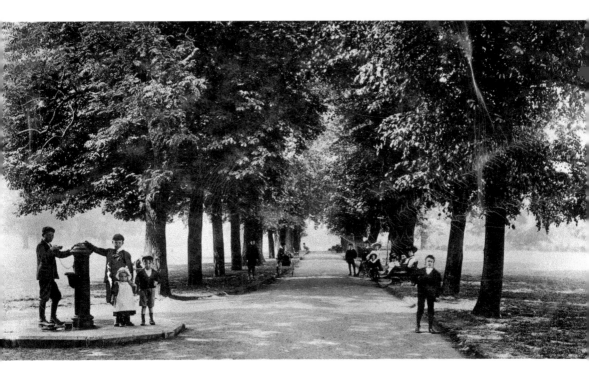

The Avenue, Walpole Park

The first picture shows The Avenue some years after the park was purchased by the council. Note the water fountain to the left, installed by at least 1915, and important for providing visitors with a free drink. However, by more exacting modern standards, this would hardly be rated hygienic. By 1956, the fountain had been moved and now a children's play park stands on the site.

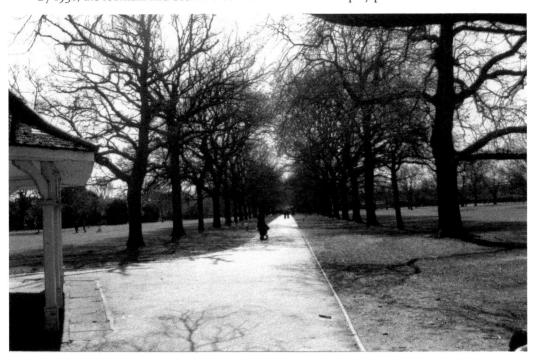

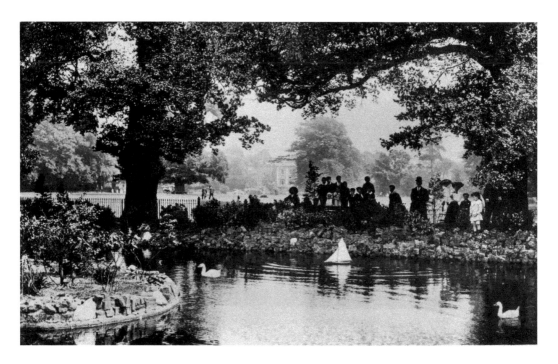

The Pond, Walpole Park

This is the more recently constructed of the two ponds in Walpole Park, with boats and birds, watched by an admiring audience, with Pitzhanger Manor visible in the background. Charles Jones explained that, 'In the winter of 1904/05 considerable difficulty was experienced in providing work for the unemployed of the Borough, and the Council decided to supply the one thing wanting in the park. A scheme was prepared, and during the winter and spring the lake was formed, not only adding largely to the tone of the park, but providing a point of interest and amusement to the hundreds of young people of the surrounding neighbourhood.' It still does, though fowl and boats are less common sights. Photographers found this pond to be a popular scene.

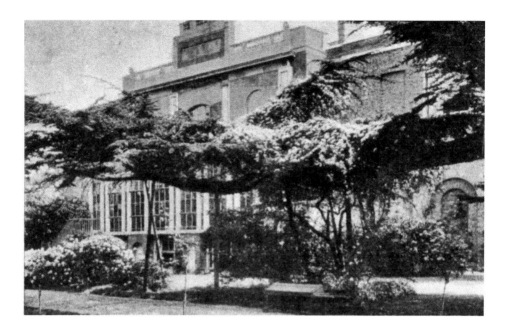

Rear of Pitzhanger Manor

This card shows the rear or west view of the Manor House, as the building was called in the late nineteenth century – it was renamed Pitzhanger Manor in 1902 when it was opened to the public as Ealing's public library. In the decades from 1843 to 1900, it was home to the surviving spinster daughters of Spencer Perceval, before it was sold to the council. As the writer of the postcard, Colin, notes, the grounds were open to the public on Wednesday 1 May 1901 in a ceremony presided over by Ealing's MP from 1885 to 1906, Lord George Hamilton, once Secretary of State for India. Who Colin was is another question, though he wrote that 'I was pleased to attend' the grand opening. This message makes this card unique, and the writing on postcards is often of great interest. Happily, the building from this viewpoint has little changed. It was renamed Pitzhanger Manor after it ceased to be a library, because that was the name Soane used for the house. Currently plans are afoot for alterations to the house and grounds with Heritage Lottery Fund money.

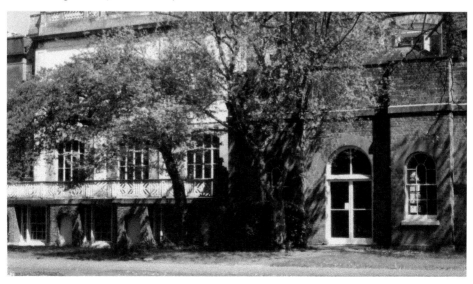

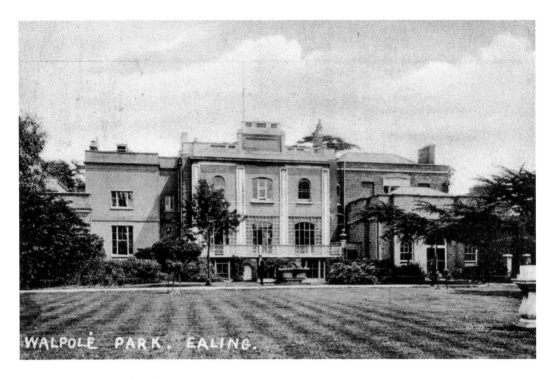

WALPOLE PARK. EALING.

Another Rear View of Pitzhanger Manor

This view is of the western side of Pitzhanger Manor, first seen shortly after purchase by the council for use as a library. The tree that obscures the Manor House in the modern view was planted in December 1997 to commemorate the life of Princess Diana of Wales, who died in a car crash in Paris earlier that year. One unusual feature of the house is that there are free-standing Classical figures.

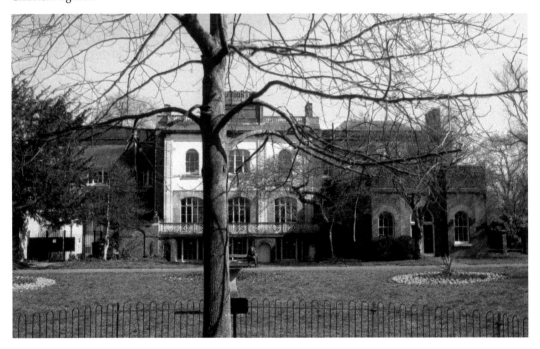

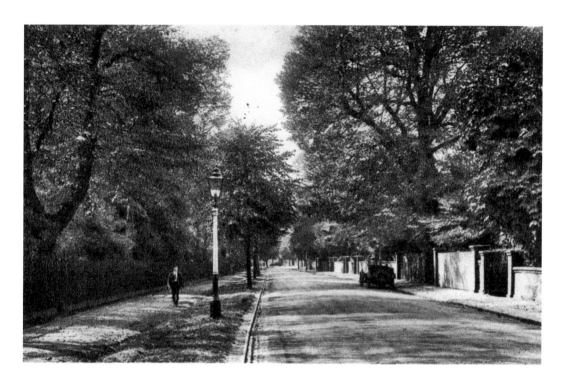

Mattock Lane

Mattock Lane is one of the oldest thoroughfares in Ealing, dating back to the late seventeenth century as Maddock Lane, possibly from Roger Maddocke of a century before. The postcard shows the generous grassy bank and pavement on the left hand side. In the 1950s, to accommodate increasing car ownership, the eastern section of Mattock Lane was transformed into car parking spaces, but further to the west, towards St John's church, much of this has been retained and the road there is rather narrow.

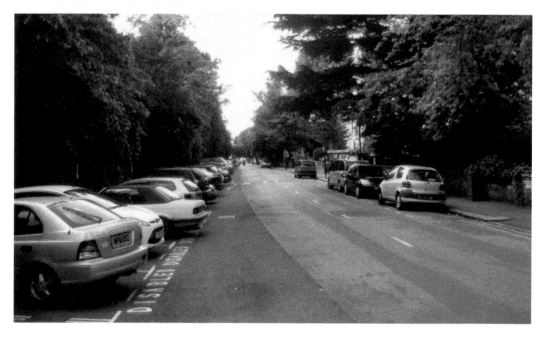

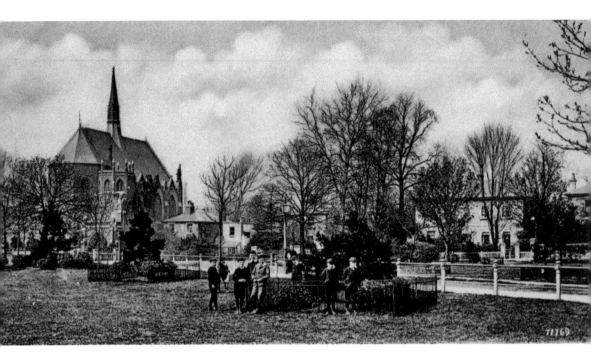

Baptist Church, Haven Green

The 10-acre Haven Green is not Ealing's largest open space, but it is the one that most visitors and residents are aware of because they cannot fail to see it when travelling to, or alighting from, Ealing Broadway station. The Haven Green Baptist church, seen in the background, and founded in 1880, remains a prominent landmark at the northern side of the green. Much of the peace of the area is no more, with buses and other transport traversing the roads around the Green, as was not the case in the earlier view.

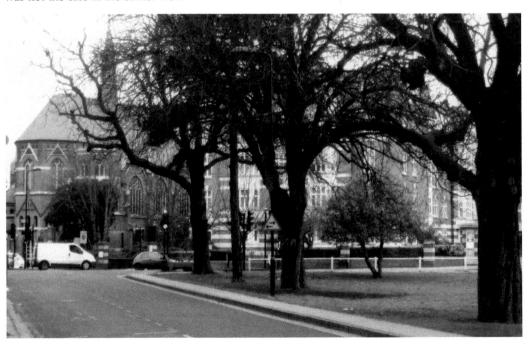

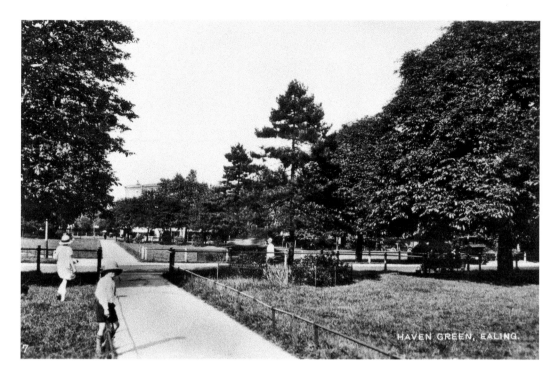

Haven Green

Haven Green, looking southwards towards the parade of shops running eastwards from the railway station(s). In 1905, the shops here were the offices of Arthur Howard and also John Kennett Brown, both solicitors, Cole & Hicks, estate agents, and the offices of the Water Board. A century later, restaurants offering a variety of cuisines are located there, together with a chemist and a mini-supermarket.

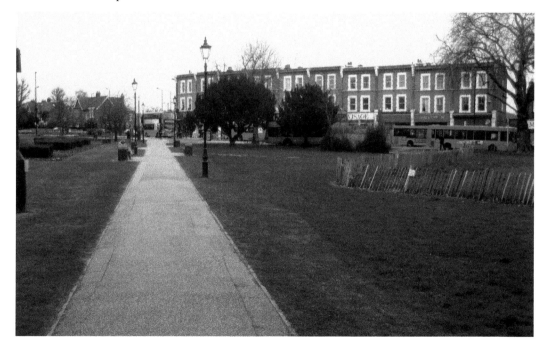

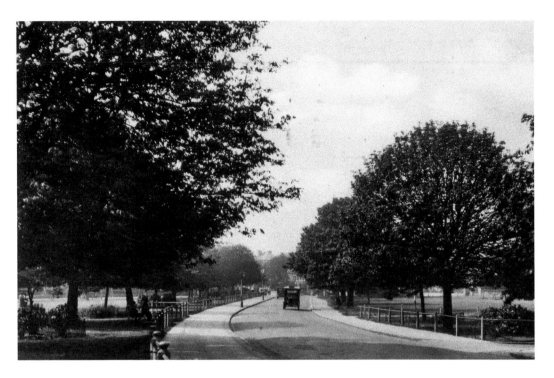

Haven Green

Haven Green, looking northwards. From a peaceful road in the 1900s, though seen here with a motor car in the background, it is now a thoroughfare for a number of bus routes, chiefly those running northwards to Greenford, Pitshanger Lane, and elsewhere. There have been roads around Haven Green since at least 1777, but these were enlarged in 1923, much to the anger of Fred Perry's father, an Ealing resident.

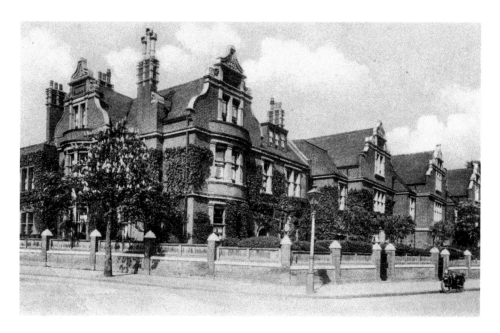

Harvington School

This picture of Harvington School must have been taken after 1915, because that is the year that the school first acquired this name. Founded as a kindergarten in Gordon Road in 1890 by the two Misses Watsons, it had initially been called the Heidelberg School because the German teacher who taught Miss Christine Watson had been born there. Yet, as with many other names, anything German had to be altered during the First World War. The school was based at No. 26 Castlebar Road from 1898, but by 1923 it occupied Nos 20–26. It was then a private girls' boarding school for ages three to eighteen until the Second World War. Thereafter, it became a day school. In more recent times it has contracted, and since 2010 caters for ages three to eleven. Number 26 is now the pre-prep school for Durston House, another local private school. Ealing was prominent in having some fine educational establishments within its boundaries, which added kudos to its respectability.

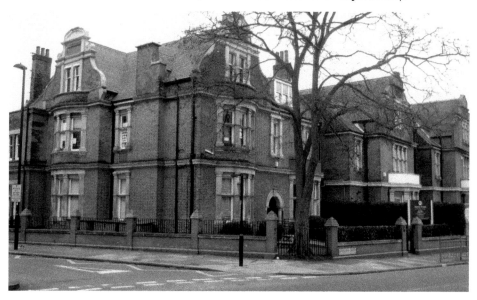

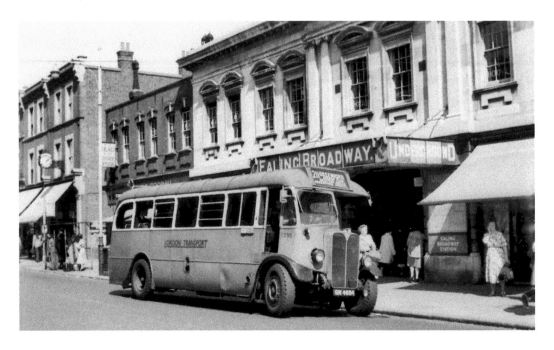

Ealing Broadway Underground Station

Ealing Broadway station has been Ealing's chief Underground terminus since the late nineteenth century. The postcard shows the station in the 1950s, when it was only the station for the Central and District lines. Although the building (and the station's name on it) survives, the Underground trains are now accessible a few yards to the right of the picture by the station, which was redesigned in the 1960s and merged access to the underground and overland lines. Buses, however, still pull up outside this site. Because each station was adjacent to the other, there was no space for shops between the two, but now there is a fast-food establishment and a newsagent there. The shops to the left of the gaming shop, in 2013, include a solicitor's, a bakery, a grocery and a bar.

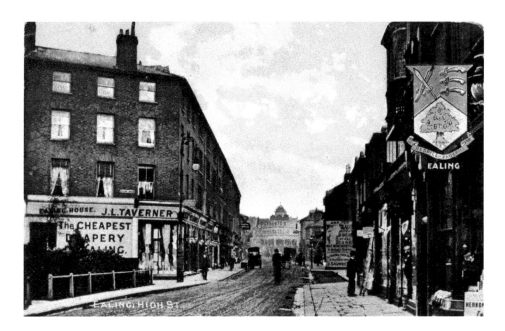

Ealing High Street

Ealing High Street is not unchanged. The shop on the left of the old picture was a draper's from 1906–11, run by John Lethbridge Taverner, but has since become O'Neill's, an Irish-style pub. The reason for this shop's prominence in the postcard is because it was published by one J. L. Taverner! Ironically, on the right side of the road was a pub called The Three Pigeons, which was later renamed but is now a restaurant. The coat of arms on the right of the postcard is that of the borough of Ealing, adopted in 1902 and remaining until the end of the old borough in 1965. The straight swords represent the diocese of London, the curved swords or knives, the county of Middlesex, and the tree is a common insignia on coats of arms, representing prosperity. The motto underneath is 'Respice, Prospice', or 'Look Backwards, Look Forwards'. At the far end of the High Street in the old picture is Sayers, one of Ealing's oldest departments stores (*see page 17*). The new picture shows the west side of the Ealing Broadway shopping centre, opened by the Queen in 1984.

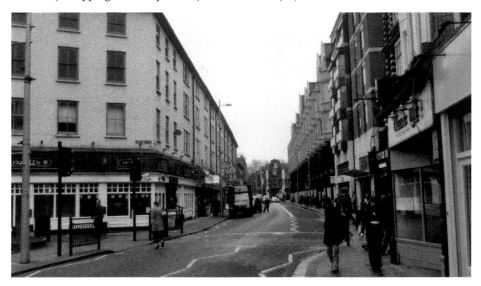

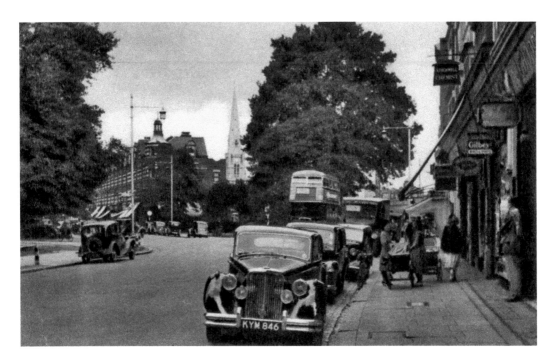

North End of Ealing Green

The north end of Ealing Green, just south of the High Street, seems to have been equally as busy in the 1920s as in 2013. To ease congestion, cars are no longer allowed to park there (parking in Ealing is not easy). The principal buildings are still on the High Street, though the police station and post office have been relocated. Other shops there in the 1920s included Lamerton's, the furniture store, and Wakefields, the photographers. By 2013, though, they had been replaced by an Oxfam bookshop, restaurants, a health food shop, a ladies' underwear shop, a Polish delicatessen, and a tattoo parlour. As ever, Christ Church's spire is a fixed point in a changing age.

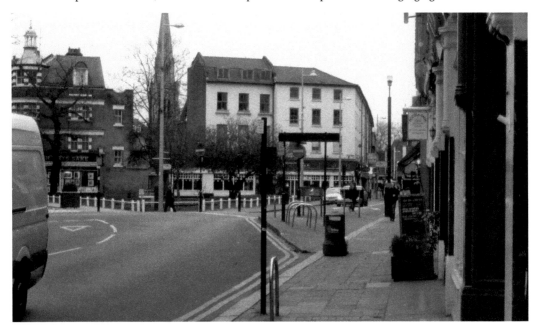

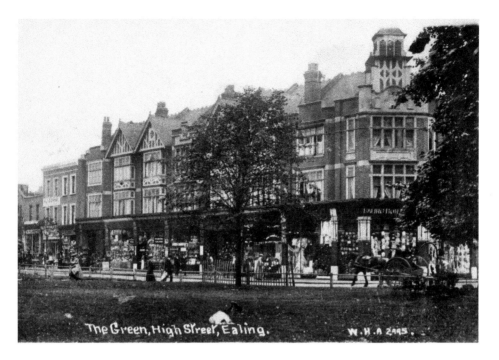

The Green, High Street, Ealing. W.H.A 2495.

Ealing Green

This view of the shops on the east side of Ealing Green has not altered too much. The shop in the right-hand corner in 1905 was John Bartlett's, the coal merchant. The other shops then on this parade were James Pettigrew, watchmaker, John Snell, bootmaker, Charles Flyman, tobacconist, John Turner, draper, Tom Thomas, provisionmaker, Timms and Gould, chemist's, and Thomas Bowing, confectioner. They have been replaced in 2013 by hairdressers, cafés and two branches of Oxfam. In August 2011, there was serious rioting here and several of these shops were badly damaged.

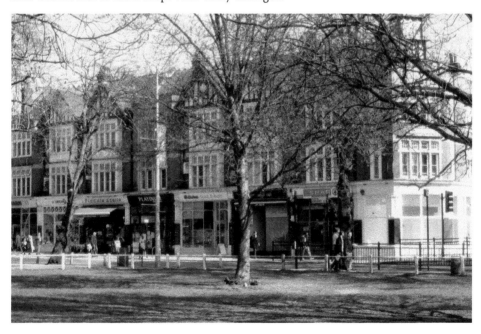

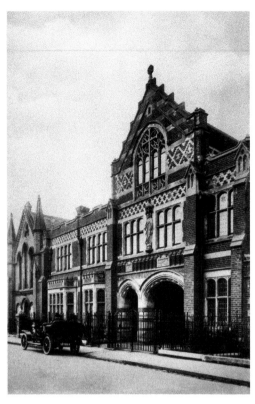

Clergy House

The Clergy House on the north side of The Grove was opened by the Bishop of Kensington on 7 May 1910. It was to provide living accommodation for the clergy of the nearby St Saviour's church, and to act as a parochial clubhouse. It contained a reception, refectory, kitchen and servants' quarters. After the parish was merged in 1952, it was known as the Clergy House of Christ the Saviour.

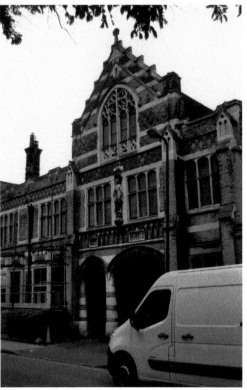

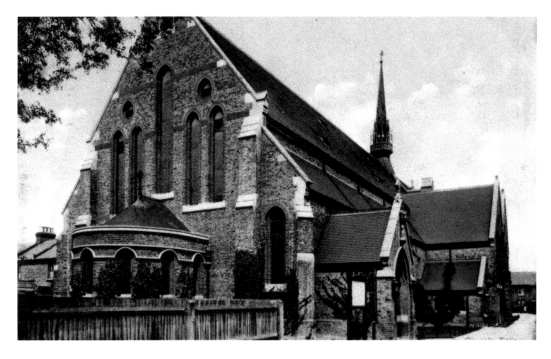

St Saviour's Church

St Saviour's church was designed by George Fellowes Prynne, who also designed the Clergy House, in 1898. Jones referred to it as 'the present substantial and commodious structure'. In 1916, the church was allocated a parish of its own. For many decades, though, it has not existed, for on the night of 16 November 1940 German bombs destroyed the church. Despite hopes of rebuilding, as in the case of St Benedict's, it was not to be. The parish merged with Christ Church (*see page 14*) in 1952. In May 1957, the county council bought the land on which the church had stood for £3,400 from the diocese, in order to expand St Saviour's Primary School, which it subsequently did.

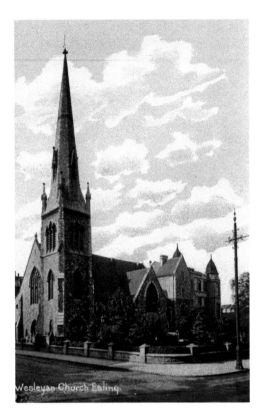

Wesleyan Church

This was Charles Jones' second significant building project in Ealing, albeit in conjunction with John Tarring (the church's spire is probably mainly owing to Taring, as he designed a similar one for a Clapham church). Up to 1865 local Methodists worshipped in the Congregational church on the Green (*see page 43*), then in the Methodist school. In 1867, the two architects were commissioned to build this church, which cost £5,500, much of which was contributed by Mr and Mrs Budgett. It opened for worship on 9 June 1869. However, just over a century later it closed and in 1986 was consecrated for use by Ealing Polish Catholics as Our Lady Mother of the Church, and run by the Marian Fathers. It also serves as a social centre, restaurant and crypt.

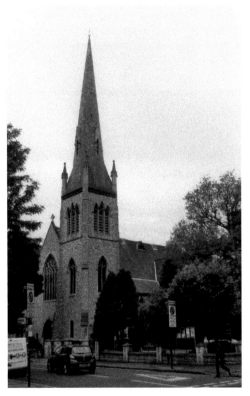

South Ealing

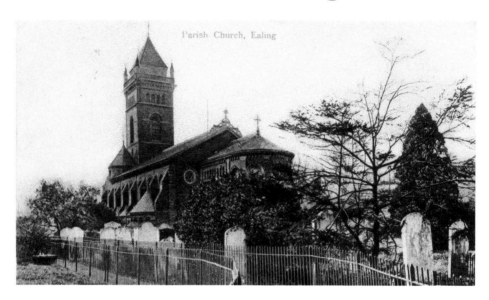

St Mary's Church

St Mary's church is the parish church of Ealing, and until 1852 was the only Anglican church in Ealing. There has been a church on this site since at least the twelfth century, though the medieval church collapsed in 1729 and was not rebuilt until 1740. This is a view of the eastern side of the church, which was remodelled in the 1860s by Samuel Sanders Teulon (1812–73), at the cost of £20,000. Jones related that this was 'the conversion of a Georgian monstrosity into a Constantinopolitan basilica'. Some of the gravestones have been levelled in more recent years for safety reasons. What has also changed is the interior, which has undergone restoration in recent years and produced splendid results. A visit is highly recommended.

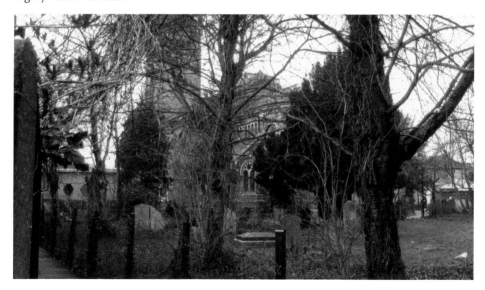

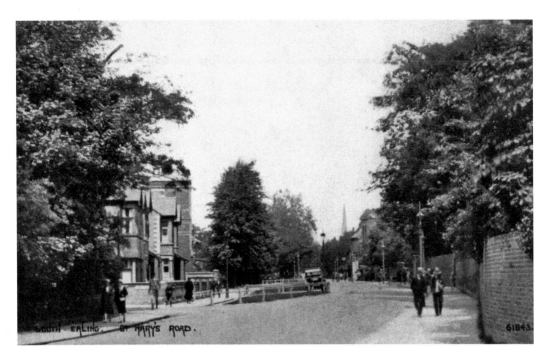

St Mary's Road (North)

This northwards view of St Mary's Road has not changed much in decades. Until the late nineteenth century, this was one of the principal thoroughfares of the village, leading northwards from the parish church, and a number of fine houses once stood here. To the right, behind the wall, was once the vicarage, until it was demolished in 1969; a YMCA hostel has stood on the site since 1985. To the left is Cairn Avenue and Nicholas Avenue, the latter named after Dr Nicholas, proprietor of the Great Ealing School.

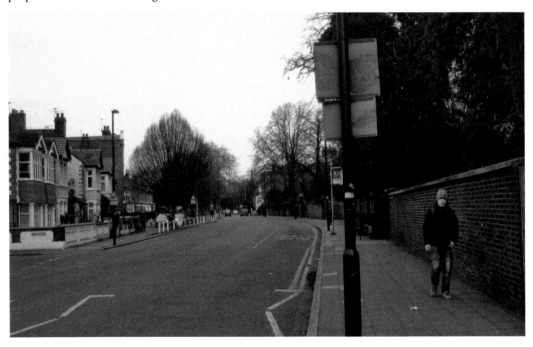

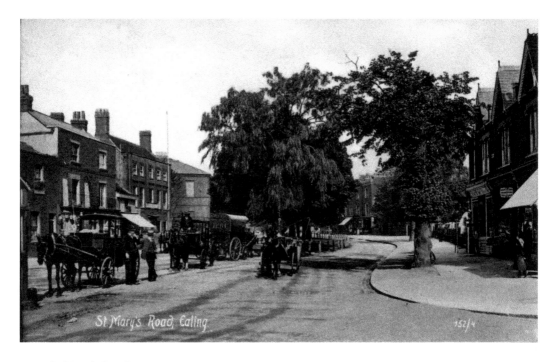

St Mary's Road

This view is of St Mary's Road, looking northwards, with Ranelagh Road just visible on the right. It is, and was, a shopping thoroughfare. At the time of the postcard, the shops on the left-hand side of the road were Arthur Trafford's ironmongers, Joseph Diment's plumbing business, George Gray's tobacconists and the Ealing Liberal Club. Most of these businesses are long gone, but there is clock shop on that side of the road now. On the right side were Arthur Hall's bakery, Joseph Bengolds' hairdressers and confectioners, and Thomas Tearle's greengrocers. A café and an off-licence have since taken their place.

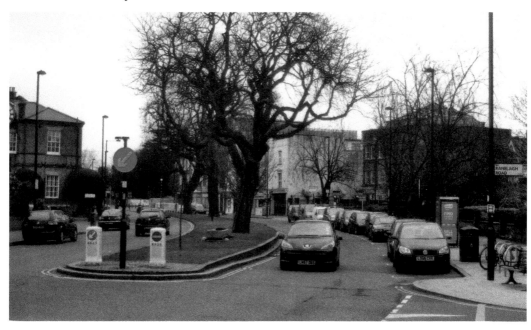

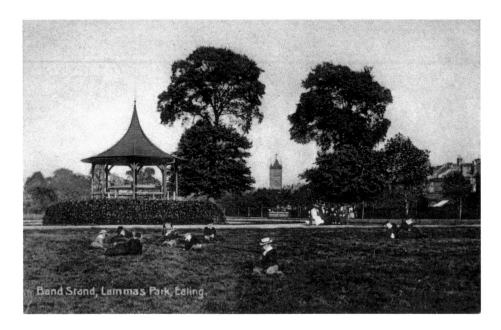

Band Stand, Lammas Park, Ealing.

Lammas Park

Lammas Park was Ealing's first park, purchased in October 1881 at the rate of £220 per acre. There had been concern in 1880 about the future of this land, and Charles Jones was asked by Edward Montague Nelson, a leading councillor, to contact the owners 'and to leave no stone unturned to obtain right of purchase'. Jones later stated, 'Lammas Park will be retained in perpetuity for the recreation of the people ... it is universally felt that it was a wise and farseeing policy that led to the purchase.' Prominent in the older view is the bandstand. Once a common sight in parks from the late nineteenth to the mid-twentieth century, they are now relatively rare. Initially they provided a venue for the Ealing Town Band, which performed locally in the summers. This 25-acre park also contained grounds for playing various games – football, bowls and tennis – as well as flower beds. The tower of St Mary's church (*see page 39*) in the background remains a fixed point in both pictures.

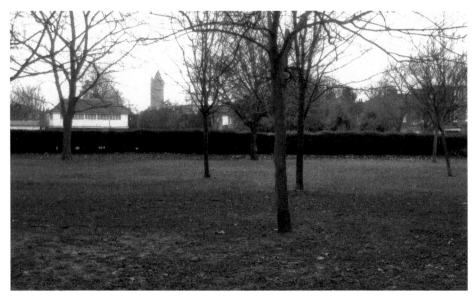

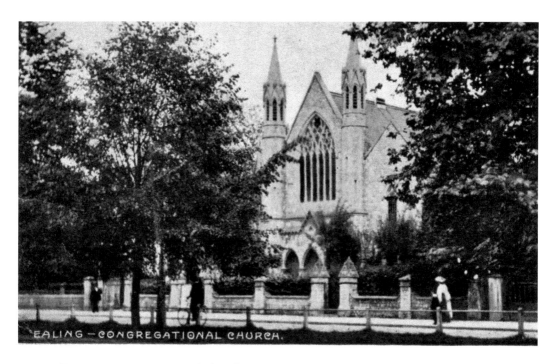

Ealing Green Congregational Church

The Congregational church on Ealing Green was the brainchild of the minister from 1856–74, the Revd William Isaac. The architect was Charles Jones, in his first significant Ealing commission (he arrived in the village with his wife in 1856), and several years before he took the council's shilling. The cost of the site and the building amounted to over £6,000 and was built in 1859/60. From 1972, the church has been used by the United Reformed church and the Ealing Methodists. Just visible in the more recent picture is the new porch, which transforms the front of the church.

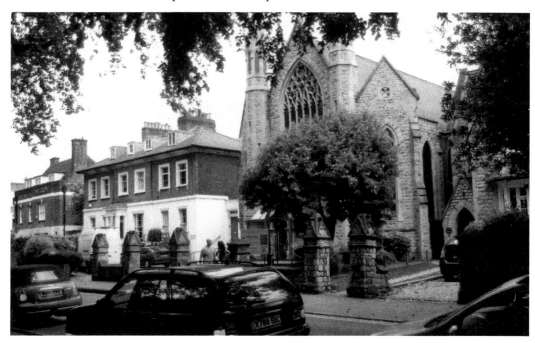

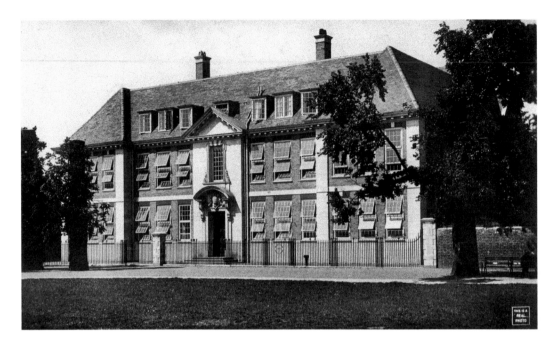

Ealing County School

Built on the site of Sir Spencer Walpole's old home, The Hall, the County School opened in 1913, and was Ealing's premier state secondary school for boys. Initially it educated 330 pupils and was also used for art and technical courses in the evenings. The school was later renamed Ealing Grammar School for Boys, and was expanded in 1936. With the introduction of comprehensive education, the school was yet again forced to change its name to Ealing Green High School in 1974. In July 1992 it closed and in the following year became Ealing Tertiary College, for pupils aged over sixteen. In 2002, it became a branch of West London College. Although trees in bloom obscure the building, it is largely externally unchanged between both pictures.

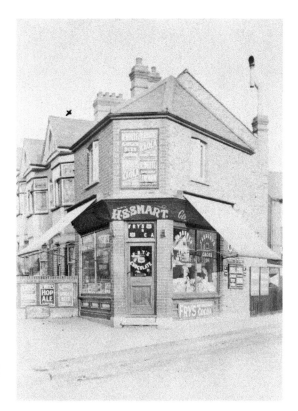

Little Ealing Lane

This postcard can be dated pretty
accurately because this confectioners
shop on 81 Little Ealing Lane, belonging
to Henry Smart, was only listed at
this location in 1908 (in the following
year Henry Smart had a greengrocers
on Chiswick High Street). This shop
remained as a grocer's and then a
general store until at least 1940. Since
then it has become, as with most houses
on Little Ealing Lane, purely residential.

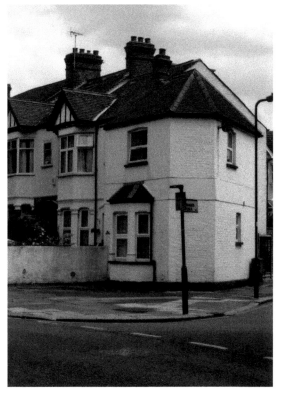

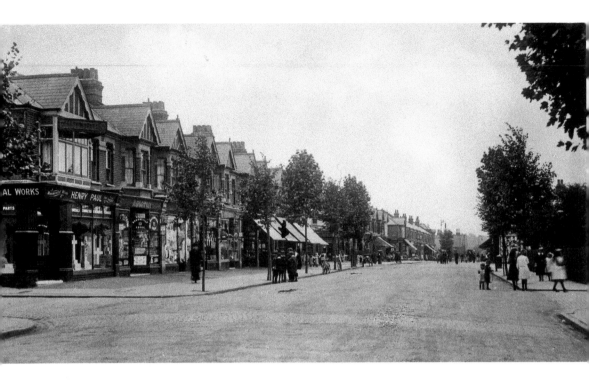

South Ealing Road

South Ealing Road had been known as Ealing Road South until around 1911. Henry Paul's monumental inscription shop had been there since around 1904, and given that 'death and taxes' are constants throughout time, the business is still there today. However, other shops here have changed. In the 1900s, those adjacent to the undertaker's were a baker's, a butcher's and a bootmaker's; in 2013 there is a fast-food place, an off-licence/general store and an optician's.

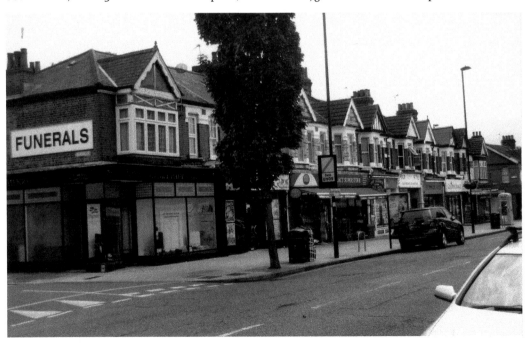

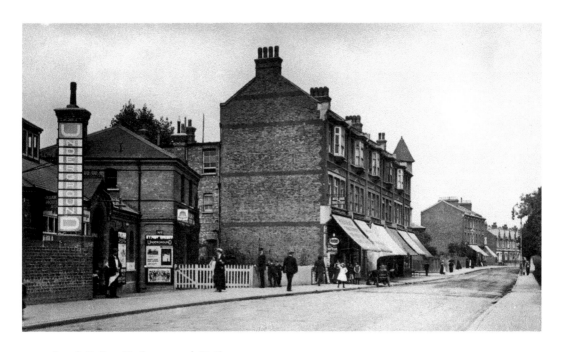

South Ealing Underground Station

South Ealing Underground station was on the Metropolitan District line from 1883, and from 1935 ran Piccadilly line trains as well, but from 1964 the District line trains were discontinued. There was a brick-built station from 1883–1932, which was rebuilt in the latter year. The current station, though, dates from 1988. It is now sited to the north of the railway line. More recently, there have been many improvements aimed at improving the customer experience. In 1907, when shops were first recorded as being just north of the station, there were Charles Wilsons' butchers, the Paris Laundry Co., H. Buck and Co., stationers, and Schuzer and Lokitz's, tailors. In 2013, these shops include a hairdresser's, a dry cleaner's, a café and an estate agent's.

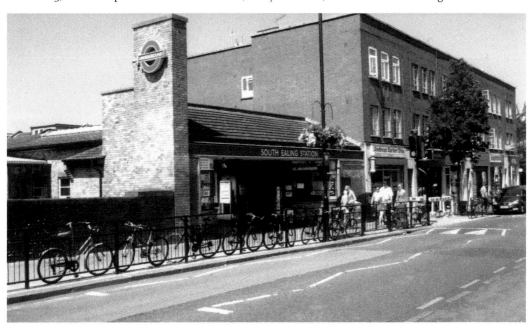

West Ealing

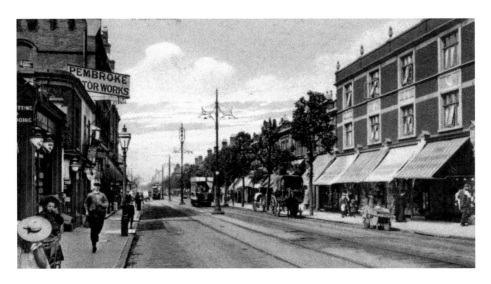

West Ealing Broadway

This view of the Uxbridge Road in West Ealing hints at the district being home to factory land, with Pembroke Motor Works advertised to the left. Although there were motor works and an Autotype Works in West Ealing in the 1900s, Pembroke Motor Works is not listed in contemporary publications, so presumably was of limited duration, at least under that name. The shop to the left of the picture was Dunkerley's hairdressers, now a bar and restaurant. On the opposite side of the road were shops such as a bootmaker's, a baker's, an optician's and a chemist's; the site has now been entirely transformed by the glass frontages partially occupied by a supermarket, but some of it lies vacant. Jay Brothers' clothiers, later men's outfitters, were in business from 1914–70. Note the fancy brickwork and very tall chimneys on the shops to the left, even in the modern view.

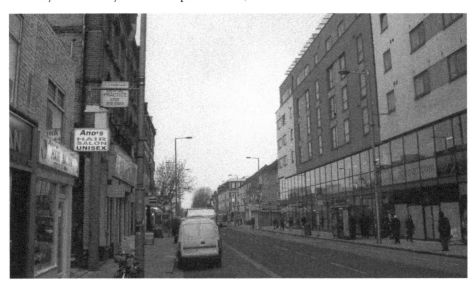

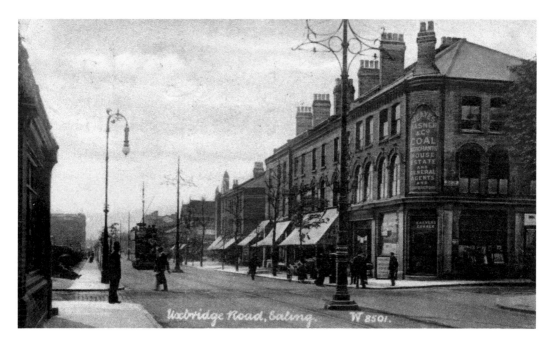

Uxbridge Road

Another view of shops along the Uxbridge Road in West Ealing. The shop given most prominence, on the right, was a branch of Jeayes and Kasner, who dealt in coal and housing, at this and other locations. They were situated here from around 1895–1919. Henry Kasner was mayor of Ealing, 1908/09, at a time when mayors were often businessmen. Coal has not been the mainstay for fuel for homes for some decades. Fast food, however, has been a vital ingredient in some people's lives, and the corner shop on the Uxbridge Road is now serving instant chicken meals. The shops to the left of Kasners in the 1900s were Alfred Tilbury's wine shop, Thomas Grant's grocery, Henry Mark's bakery and William Meer's butchers. Over a century later, a nail bar, a solicitor's, a dry cleaner's and a fruit and vegetable shop replaced these.

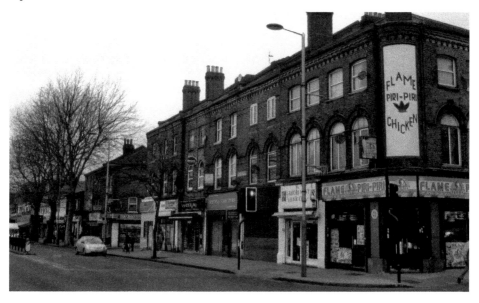

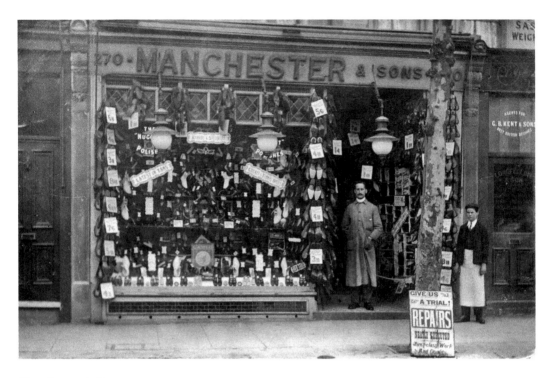

Manchester & Sons

From around 1901 to 1926, Manchester & Sons, bootmakers, was located on 270 Uxbridge Road, renumbered and renamed No. 136 The Broadway, West Ealing, by the early 1920s. Unlike many small shopkeepers, the Manchesters did not live above the shop, or even in Ealing itself. Now a community shop stands here, a sign of the times, just as the vacant premises it replaced was. This postcard is a very visually appealing view and a most rare one.

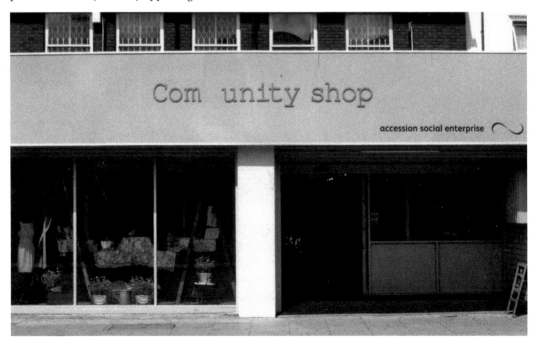

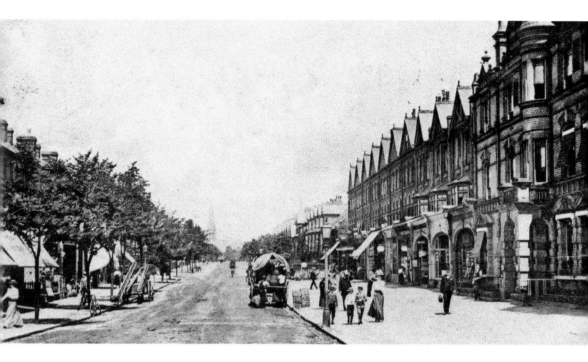

The Avenue

This view was taken looking northwards from The Avenue in the early decade of the twentieth century. To the right is the Drayton Court Hotel, then newly opened in 1894 by Edwin Stephens, who also owned The Feathers (*see pages 12–13*). Initially a residential hotel, with extensive gardens and tennis courts to its rear, it reverted to being a pub in the 1960s, but is now a hotel once more. In 1905, the shops on the same side of the road of the hotel, and to its left, were William Coles, a wine merchant, the Drayton Court Dairy, Lane Pegg and Co., a piano showroom, Alfred Lesser, a stationer, and William Cooper, a hairdresser.

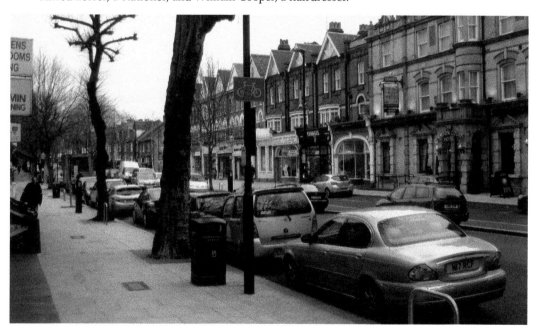

51

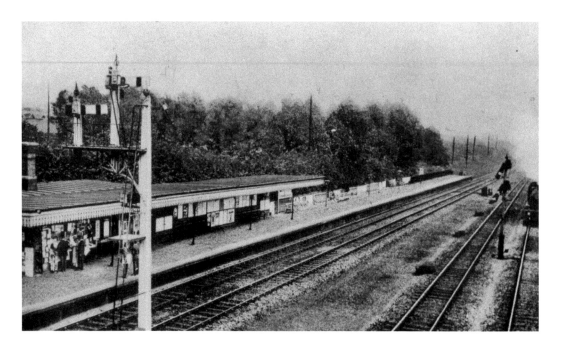

West Ealing Railway Station

Taken from the bridge over the railway, this shows West Ealing railway station at a fairly quiet moment, with only a few passengers on the left (the platform for trains leading westwards out of London) and with a steam engine just visible on the right. The picture must post-date 1 July 1899, because previously the station was named the Castlehill and Ealing Dean station (from 1 March 1871). Note the station shop on the left, which is now long gone. On the south side were a coal depot and a goods shed, now replaced by a branch of Waitrose. The station served the Great Western Railway from its outset, but from 23 June 1903 it also was part of the Greenford loop. In recent years, trains from the First Great Western from Paddington to Reading no longer stop here, but trains on the Heathrow connect line do.

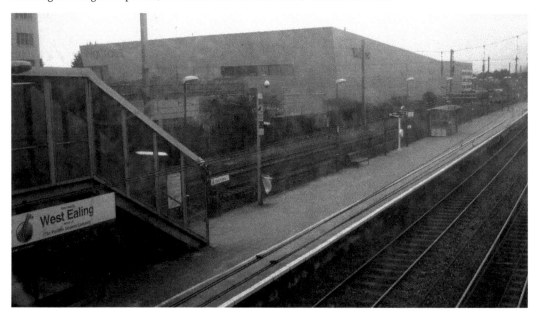

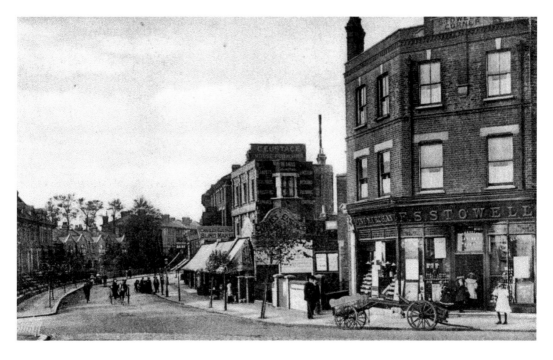

Stowell's Corner

This part of Argyle Road is dominated by Stowell's Corner now, as it was in the earlier picture, though this branch of F. S. Stowell's wine and spirits merchant's has been replaced by a café. Frederick Stanley Stowell (1849–1924) first opened an off-licence in Ealing in 1878, and by the time of his death, lived in Castlebar Road and owned numerous shops. The company was a limited one and passed to his son, Harold, later mayor of Ealing. The branch in this picture was in existence from 1902 to 1962.

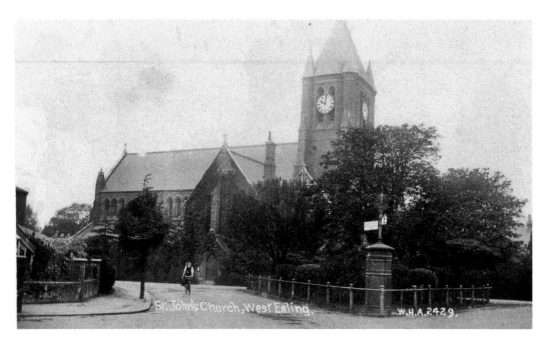

St John's Church

St John's church dates from 1876. Charles Jones wrote of it, 'So far as the structure itself is concerned, it requires a great stretch of imagination to use the term "beauty" in connexion with it – massive is the word by which it may be described – but the interior is certainly most effective, and, as seen from the western entrance, is striking in the extreme.' The view is now radically different, as can be seen. This is because the church suffered from a fire in November 1920, which resulted in it having to be completely rebuilt (minus spire) and was re-dedicated in 1923. It has changed but little externally since then.

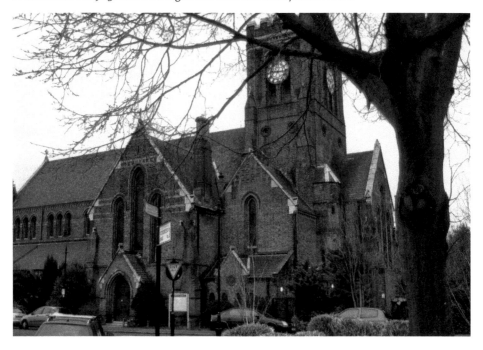

Loveday Road

The houses in Loveday Road, seen here, looking northwards towards St John's church, were built between 1901 and 1904 by a number of builders: Wallis and Watts, Mr G. A. Gale, Edwin Evans and Messrs Pickering & Besant. Although it appears that little has changed, two points should be made. Firstly, on 20 September 1940 a high explosive bomb fell and resulted in one house having to be rebuilt in 1946/47, though no one was killed. Secondly, some houses have had extensions, added bathrooms or garages, or were converted into flats.

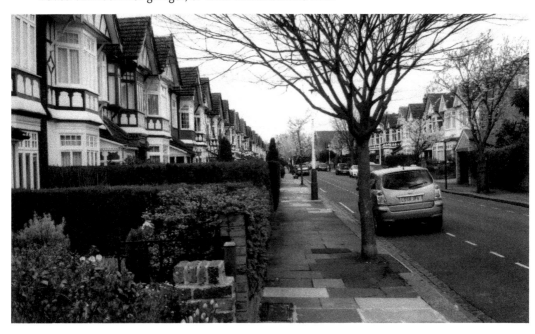

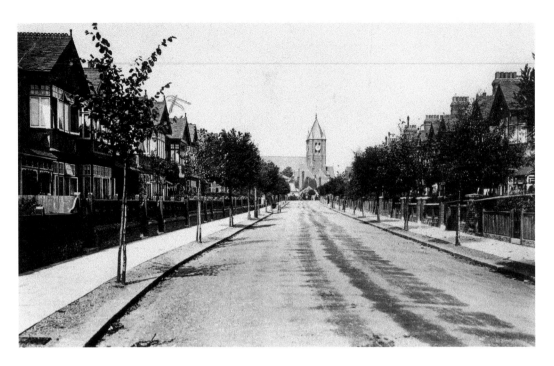

Lavington Road

Again, the basic structure of this street has remained largely unaltered from its construction in 1901–03. Its name probably comes from Lavington in New South Wales. Several other streets in west Ealing have Australian inspired names: Adelaide Street, Brisbane Road, Sydney Road. This is because of the Steel family, who were market gardeners in west Ealing, had dealings in Australia. Again, a number of builders put up these houses: all those mentioned on the previous page, plus Sanitary Building Company and Mr J. W. G. Mills. In both cases, the roads were laid out in 1898 by Mr G. E. Law.

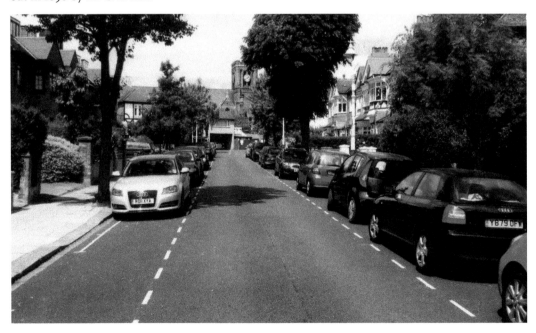

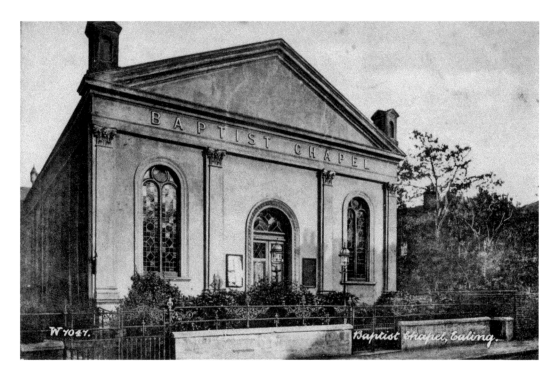

West Ealing Baptist Chapel

West Ealing Baptist chapel was on the east side of Chapel Road, and was undoubtedly the reason for the naming of this little road. The chapel was designed by William Mumford in 1864/65, who also designed the Acton Baptist chapel at the same time. The first minister was the Revd Archibald Ferguson, who served there for twenty-eight years. Over the years a schoolroom was added, as was a porch in 1927. Since 10 August 1991 it has been a Hindu temple, the Shri Kanaga Thurkkai Amman Kovil, indicative of Ealing's increasingly diverse culture.

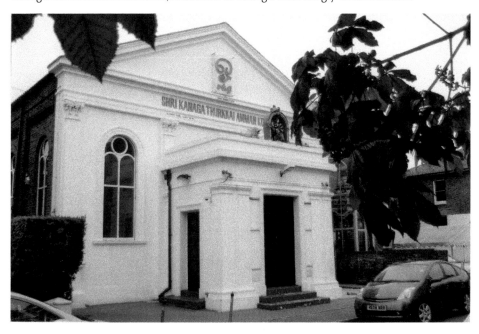

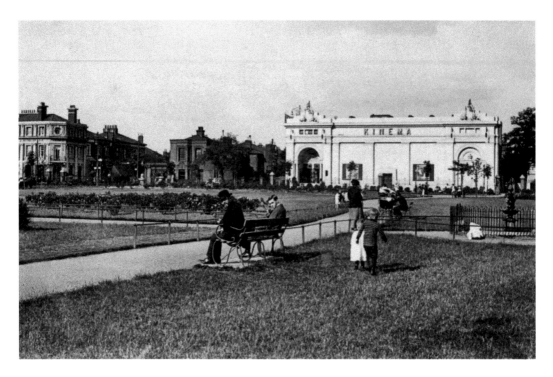

Dean Gardens

West Ealing's first open space, after the district was built up, of 3 acres, was on the site of former allotments. It was declared open in 1909, but only after a public enquiry to determine whether the land usage could be legally altered. The water fountain seen here was installed by a Miss Jeafferson. The background is dominated by the Kinema, Ealing's second purpose-built cinema, built in 1913, which was rebuilt in 1928 as the Lido. However, it closed in 1965, only to reopen as a bingo and snooker hall, and then to show Indian films. At the onset of the twenty-first century it closed, and in 2005 was demolished to make way for low-rise flats.

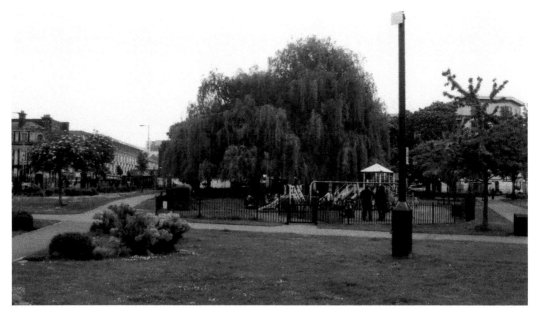

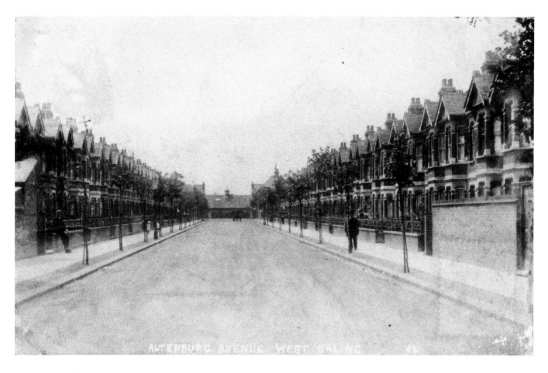

Alternburg Avenue

This view of Altenburg Avenue has altered in the same way as the other views of residential streets that feature in this book. The houses were built in 1905. It is noteworthy that in the rush to change the name of anything remotely German during the First World War, this road name did not change. Altenburg is an east German town, renowned for its manufacture of playing cards.

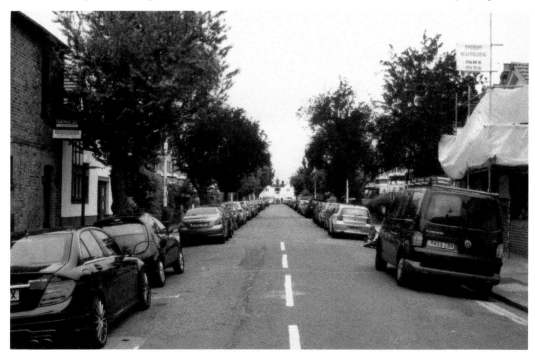

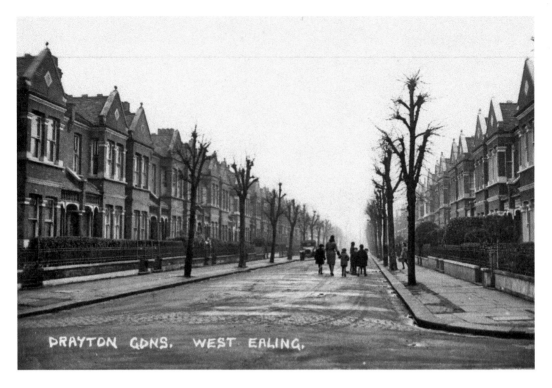

DRAYTON GDNS. WEST EALING.

Drayton Gardens

Drayton Gardens was built in 1899–1901, and stood on what were the grounds of Drayton Green House. As with the other residential streets, what strikes the modern viewer is the lack of clutter and the openness of it all, and the fact that people could quite safely walk along the middle of the road.

Half Way House

Though this pub dates back to being an eighteenth-century daily stopping off point for the Prince of Wales coach to Oxford and Banbury, the present building dates from 1906, when Frederick Charles Seabrook was licensee. Originally known as The Old Hat and Halfway House, it adopted the latter part of the name by the nineteenth century and retained it until around 2002. After standing vacant for a year, it began business again as The Broadwalk Hotel from 2004 to 2006. In 2008/09 it was the Bless Bar, an Indian restaurant, and in 2012 became a pub again, The Lounge Bar.

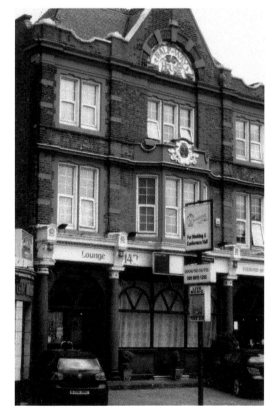

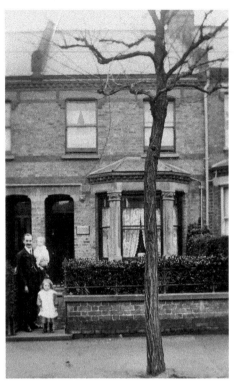

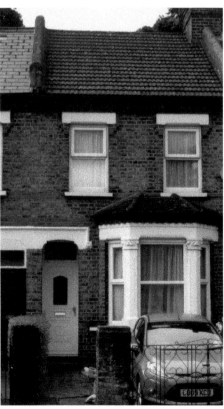

No. 58 Eccleston Road

Number 58 Eccleston Road was one of the last houses in this late Victorian street to be built, which occurred in around 1894. The figures outside the house make dating this picture even easier. The man is Norfolk-born Robert Perkins (1867–1944), and he was an insurance agent who lived here from 1908 until his death. Pictured with him are his daughters, Olive and Ethel, who were respectively four and two at the time of the census of 1911, so we can be fairly certain that this picture was taken in either the previous year or 1909.

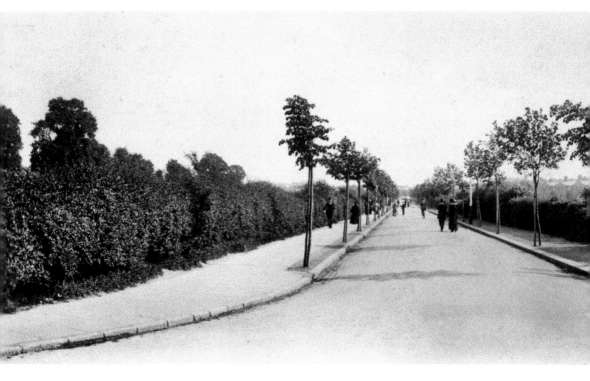

Northfield Avenue

Northfield Avenue had just been given its new name when this picture was taken (it was named Northfield Lane since at least the eighteenth century). Allotments line the street to the left, having originally been located in what is now Dean Gardens. Ealing's first hospital was located on this road.

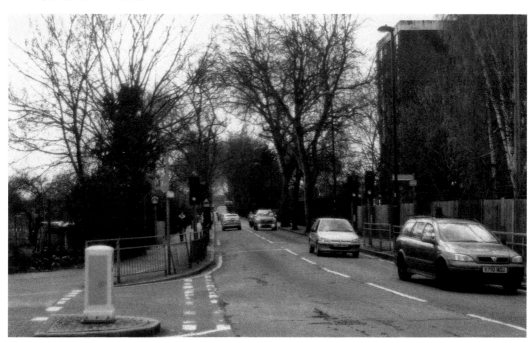

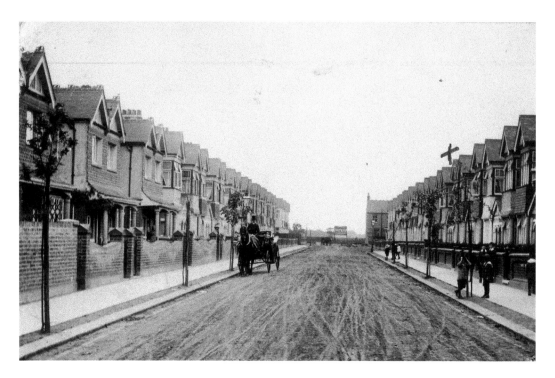

Wyndham Road

In the first decade of the twentieth century, the district to the west and east of Northfields Avenue was built up, as was the thoroughfare itself. The houses in Wyndham Road were part of the West Elers estate, with sewers laid out in 1903. The houses were built in 1907–10 by two builders, Read and Johnson. The latter may have been Jesse Johnson, of the nearby No. 109 Darwin Road. The main difference between the views, of course, is the on-street car parking.

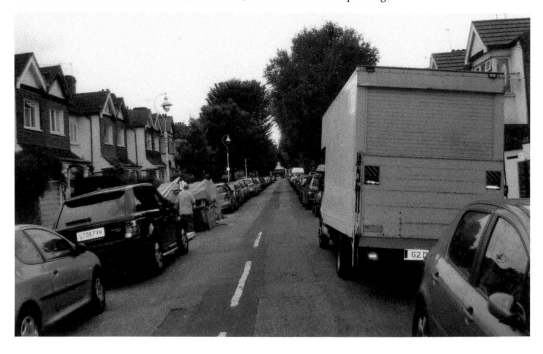

North Ealing

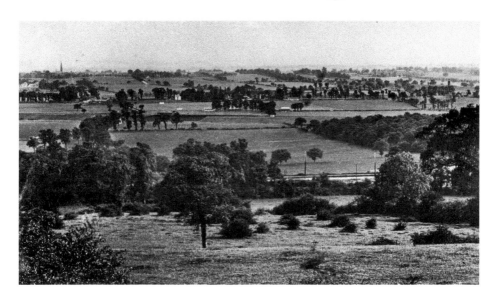

Horsenden Hill

Northern Ealing never looked so rural as when photographed from Horsenden Hill, which is in Greenford. The hill and its surrounding countryside was bought by Ealing Council as an open space in 1928, despite fears that it would become a haven for anti-social day trippers from London, to the detriment of residents. It remains the borough's largest open space and highest point. It has become far more wooded, though, in recent times, and of course, there are far more buildings in the background. Since 2006, Highland cattle and other beasts have grazed here, and on a fine day you can see adjacent counties.

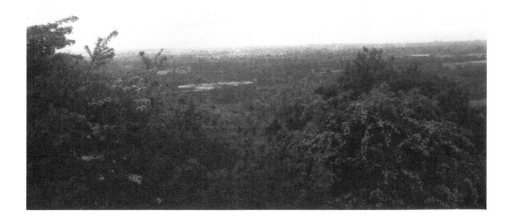

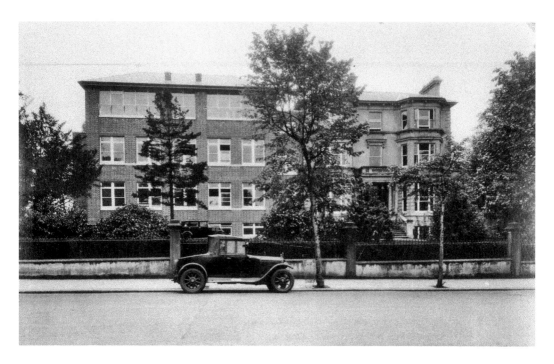

Ealing and Notting Hill Girls' School

Originally built as one of the many large detached houses in north Ealing on No. 2 Cleveland Road, it became a girls' school in the 1920s – first Lyndhurst Lodge, then Girton House School under Miss Grylls' charge. At the time of the postcard, it was Notting Hill and Ealing (Girls' Public Day School Trust Ltd), having taken over Girton House in 1930 and reopened in 1931 with Miss McCaig MA as headmistress. The school had previously been at Norland Square in Notting Hill since 1873. It was a public school for girls aged eight to nineteen. Many decades on, it still serves the same function as it did in the 1930s.

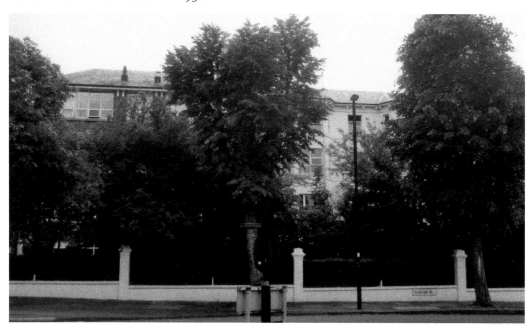

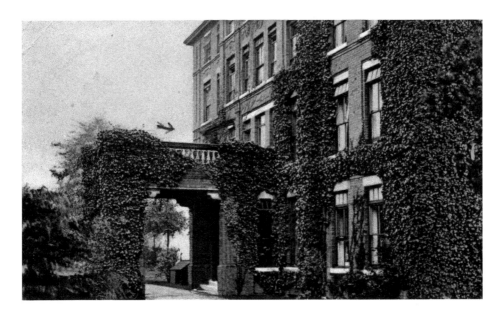

Princess Helena College

The Princess Helena College, another public school for girls, often daughters of Army officers and colonial civil servants, moved to Ealing from Regent's Park in 1882, and stood in 9 acres of land off Montpelier Road. It had a mixed kindergarten, fifty-five boarders and 100 day girls. Charles Jones disapproved of the building, noting 'the finest site in Ealing is not graced by a building which may be looked upon as a "thing of beauty and a joy forever"'. Yet the school is now long gone; it moved in 1936 to Hertfordshire, and the building was subsequently demolished. A new school was built there. This was Montpelier School, opened in September 1957. This was to relieve overcrowding from the North Ealing Primary School due to the post-war baby boom. The first headmaster was Mr Wharton BA, who had a staff of six, of whom five were female, and 190 pupils. The only visible reminder of the older school is its name on the gate.

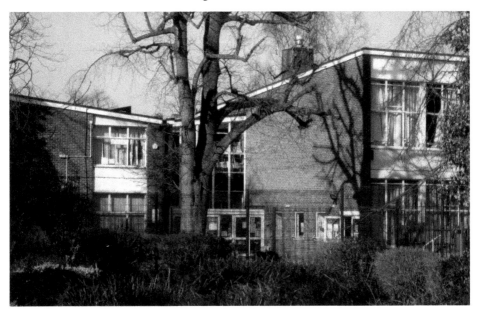

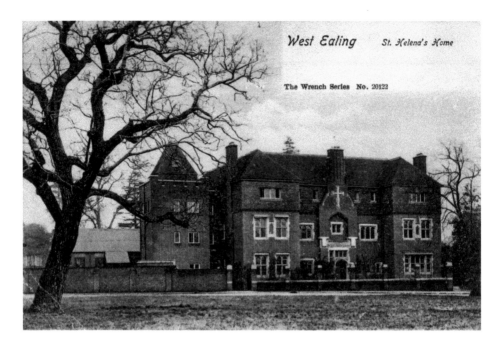

St Helena's Home

St Helena's Home was a Catholic home built on Drayton Green Road, which was founded in 1884 by nuns from St Mary the Virgin, Wantage. Its purpose was to help young women who had fallen into crime, and to reform their characters by enabling them to avoid prison experience. However, by the following decade it was felt to be too small, and so was rebuilt in 1896/97 with a laundry and a chapel attached and was opened by the bishops of Reading and London. The Home took forty girls. In recent times, it was used for other religious purposes. However, despite attempts to have it listed in order to preserve the building, it was demolished for the inevitable housing. Attempts to save it partly floundered because it could not be ascertained who the architect was – if any.

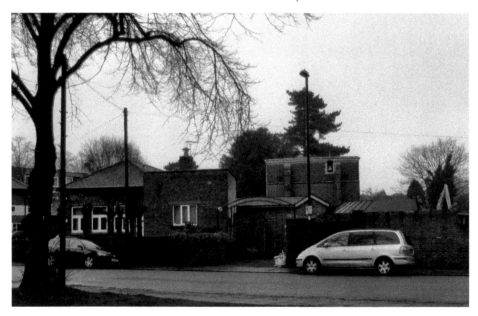

St Stephen's Church

St Stephen's church in west Ealing was designed by Mr Ashdown, and the tower and spire by Arthur Blomfield fifteen years later. It cost £6,000 and was consecrated on 3 June 1876. According to Jones, 'of these [churches], certainly in architectural beauty, stand out prominently the church of St Stephens's. Occupying one of the most commanding positions in Ealing, it forms a landmark, and makes as prominent a feature as its northern neighbour, on Harrow Hill.' However, by the 1970s the building was unsafe for use and was sold to Berkeley House plc, who converted it into twenty-two flats in 1985–87. The church downsized to a parish centre nearby.

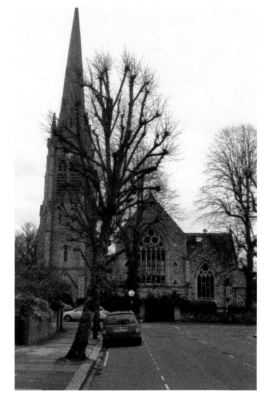

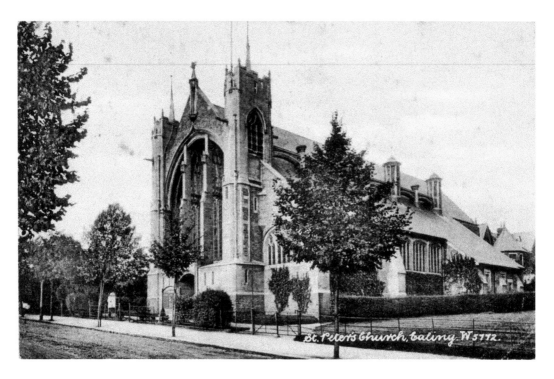

St Peter's Church

St Peter's church appears essentially the same in both views, but there is an important difference. On the right of the older picture there is open ground, but there is now a vicarage. Until 1911, the vicar had lived at No. 18 Mount Park Crescent. The Revd Austin Thompson MA was the first vicar to reside at the vicarage. The church itself was designed by Mr J. D. Sedding in 1889, and built a few years later by Mr H. Wilson. Jones wrote, 'It is a somewhat imposing structure, and of a style upon which there would naturally be some diversity of opinion.' Yet 'it supplied a much felt want in that particular portion of Ealing'.

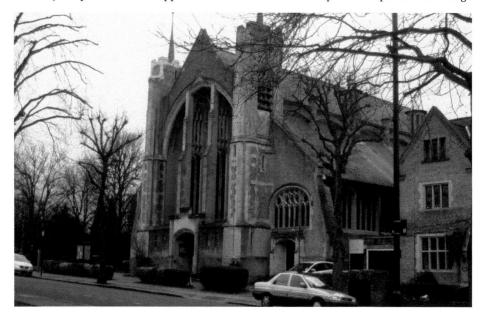

St Benedict's Church Exterior

St Benedict's church on Charlbury Grove is the most impressive Catholic church in Ealing. It was designed in 1899 by Felix Walters, and later by Edward Walters. It was enlarged in 1915, and was given dependant priory status in the same year. The nave was completed in 1934. However, on 7 October 1940 the high altar and sanctuary were destroyed by two high explosive bombs. Worship continued in 1941 but rebuilding did not begin until 1956. By this time, it had achieved abbey status.

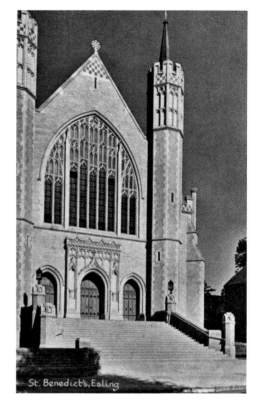

St. Benedict's, Ealing

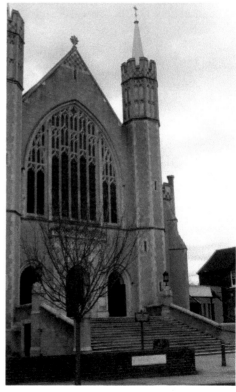

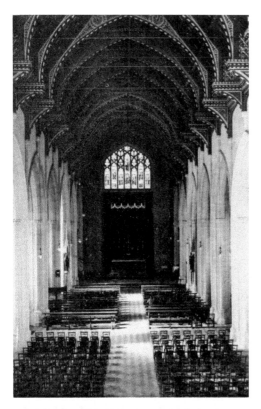

St Benedict's Church Interior

Although services were first held in the church in 1899, building work continued for over three decades and this card, produced in the early 1950s, is actually of the interior prior to the bombing, and the reverse asks for donations towards the restoration fund. The interior of the modern church was largely built in the 1950s and 1960s by Stanley Kerr Bate, and had been instituted by the first abbot, Dom Rupert Hall. A painting of St Boniface in the right aisle was paid for by the West German government in 1964. Ten years later, the church finally acquired a new organ, built by Andrew Rushworth.

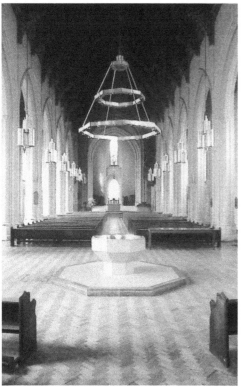

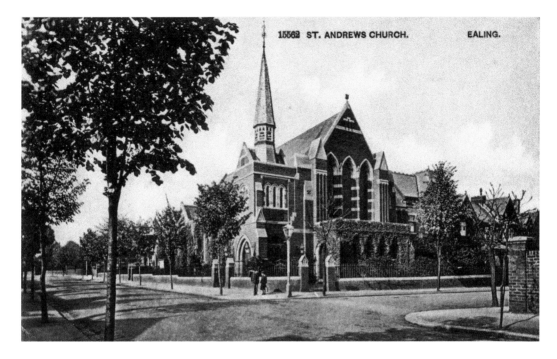

St Andrew's Church

St Andrew's church was a Scottish Presbyterian church, which was designed in 1886/87 by a Mr Wallace, at the corner of Aston Road and Mount Park Road. The foundation stone was laid on 22 May 1886 by the Marquess of Lorne. The first minister, from 1874 to 1891, was the Revd Gavin Carlyle (there had been a temporary structure since 1874). Since its inception, it has seen additions in the form of a lecture hall and club room, and in 2013 there is African afternoon worship in the church one Sunday a month. Since 1972 it has been a United Reformed church.

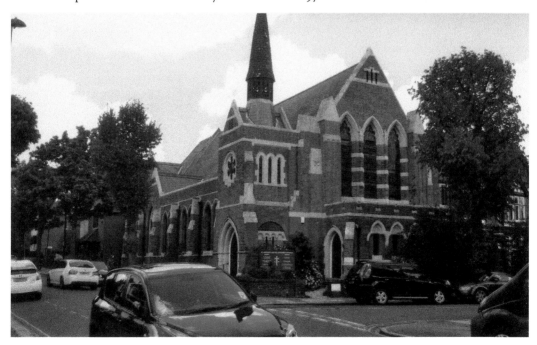

Eaton Rise

The houses on Eaton Rise were built in the 1870s. It was the home to many prominent residents in the 1900s, including Major-General Charles Robinson and four other retired officers, a doctor and a surgeon. There were also three small private schools there, and many of the houses were known by names as well as numbers. The schools are now long gone, though the trees remain, and the once empty street is lined with cars.

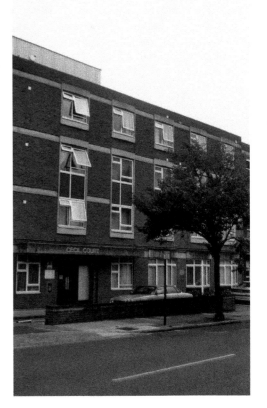

CECIL COURT, 73/75 EATON RISE, W.5

Cecil Court

Cecil Court is a private old people's home, built between 1968 and 1970 for forty-one senior citizens. The builders were G. Ward of Ealing. In 1977–79 it was extended southwards to cover Nos 71–75 Eaton Rise, at the cost of just over half a million pounds. It could then house seventy-seven residents, and the new wing was opened by Prince Philip in 1979. Since the 1980s, male residents have been permitted to live there. The postcard here dates from no earlier than 1970, and it is thus noteworthy that a postcard of a relatively commonplace building was created.

Mount Avenue

Mount Avenue was one of Ealing's more select residential streets in the 1900s. Its houses had names, not numbers; in 1905 these included Winscombe Court, Somerset Villas, Cornwall House, Red House, Balmain, Ardmore, Vine Lodge, North View and Llanberis, often reflecting the place of the owners' origins. Some of their occupants were significant figures, such as Dr Maxwel Masters, the Revd Evan Thomas, Colonel Augustus le Messurier and Francis Waring, CMG. Street numbers tended to officially replace names in the 1920s, though the latter can sometimes still be seen.

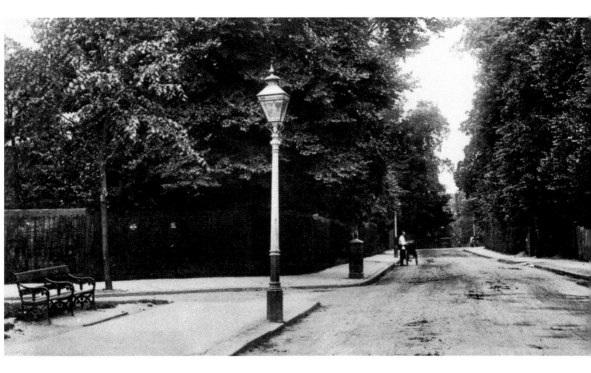

Castlebar Hill

Castlebar Hill is another road running off from Castlebar Park, and is not far from Mount Avenue. Like this other road, it was lined with detached houses of the well off. As with Mount Avenue, the houses were once known by names; St Angelo, Cwm Avon, Fennymore, Kent House, Courtfield Lodge, Hillcrest, Netherleigh, Wyke House and Cadbyrie House, and were dwelt in by the affluent, such as Harold Aston, a solicitor, and Richard Read, a civil engineer.

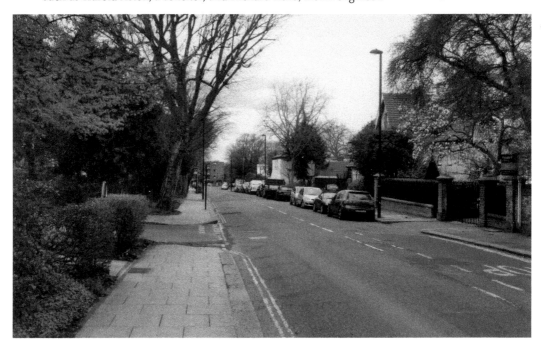

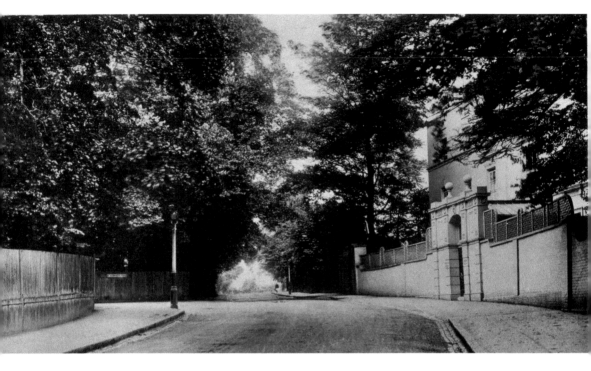

Castlebar Hill

Castlebar Hill is still a desirable and thus expensive part of the borough. It derives its name from 'castlebeare' in 1675, which is a reference to a large house/castle and a wood/grove, both of which are indicated in the postcard. The lodge of Castlebar Hill Park can be seen on the right. Part of the house still survives as St David's Home for disabled servicemen, founded in the aftermath of the First World War.

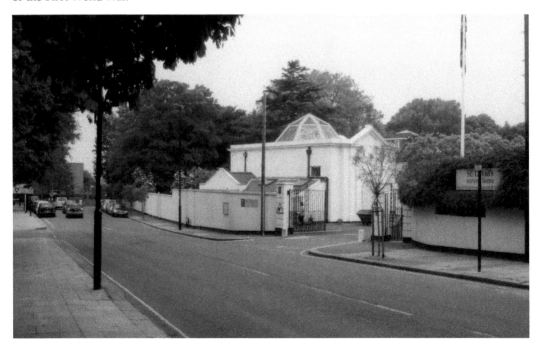

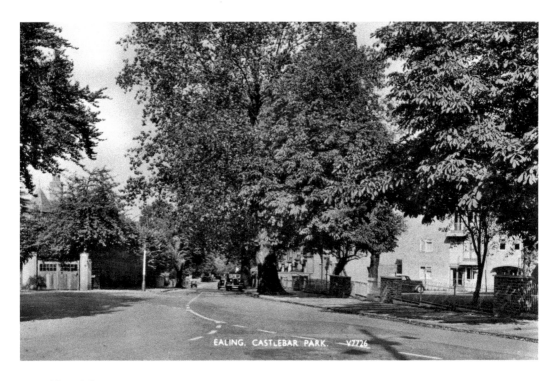

EALING. CASTLEBAR PARK. V7726

Mount Avenue

Who says that postcard captions never lie? This postcard states that the picture here is of Castlebar Park, but is actually of Mount Avenue, which is two streets away. To the left of the postcard is the gateway to Colombe Lodge, now demolished and replaced by the early 1960s Dene Court flats. On the right of the postcard are Mount Close flats, which were newly built at the time of the postcard (1950s).

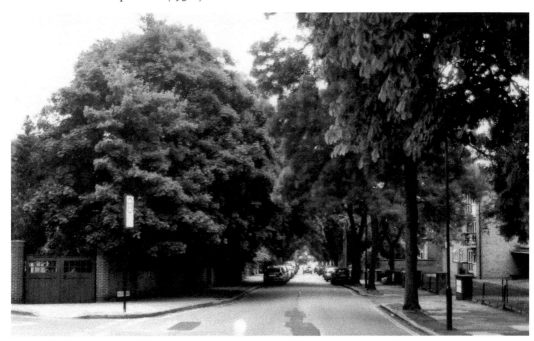

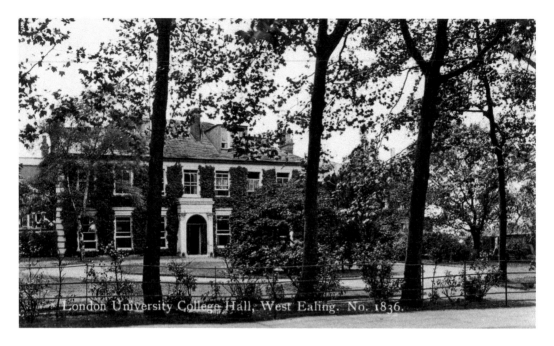

London University College Hall, West Ealing. No. 1836.

University College Hall

The postcard shows what was a private house, Castlebar Court, on the west side of Queen's Walk. In 1908 it was opened by Lord Roseberry, in his role as Chancellor of the University of London, as University College Hall, a hall of residence for thirty-seven students who attended the university, paying between 25 and 40 shillings a week. As well as bedrooms, there was a dining hall, eight bathrooms, a common room and a study room, plus 4 acres of land, including tennis courts. In 1940, it was used for Polish refugees as a school, and after 1945 was a nurses' home. However, in the early 1980s it was demolished and flats now stand on the site; the name reverted to the pre-1908 name, Castlebar Court.

Hanger Hill

Hanger Hill was never the name of a road in Ealing as the postcard implies, the road being known as Hanger Lane from the nineteenth century onwards. The confusion may arise from the large house known as Hanger Hill House (now demolished), which was on its eastern side, and the fact that the road slopes upwards from Ealing Common. Until the 1930s, most of the land on both sides of this road was occupied by farms and detached houses, such as Greystoke House and the aforementioned Hanger Hill House. These are no more, but the road is still as tree-lined as ever it was, and some open spaces have been retained for public use.

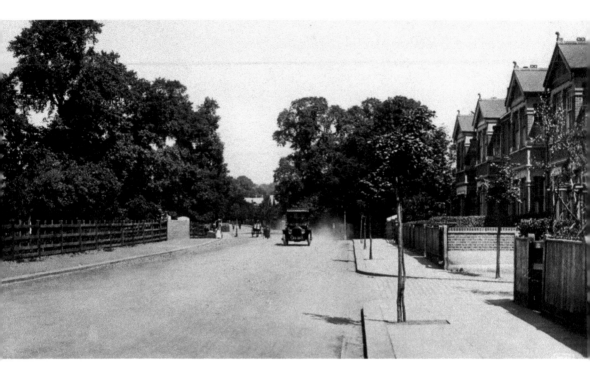

Hanger Lane

The south end of Hanger Lane was built up in the 1880s, and this scene shows Nos 14–20 between Freeland Road and Inglis Road. This was one of many parts of Ealing in which the middle classes lived; in 1905 they included Dr William Beecham, Miss Roberts, Gustave Cornioley and Richard Fleming St Andrew St John MA. Along Freeland Road at that time were Basil Holmes, an Ealing councillor and two colonels.

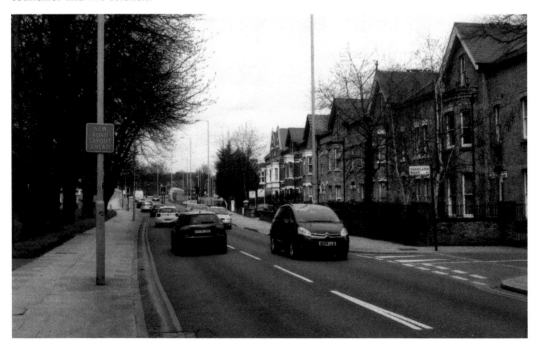

Audley Road

Audley Road was built in 1929 as part of the Haymills estate, which was one of the later housing estates in Ealing. It was named after Lieutenant-Colonel Sir Audley Dallas Neeld, who had dealings with the Haymills company when they were working in Hendon. There has been relatively little change, except that the chimneys no longer exist, and a parking notice outside gives permitted hours of parking. One of the street's best known residents was the organ builder, John Compton, who was honoured by a blue plaque in 2013.

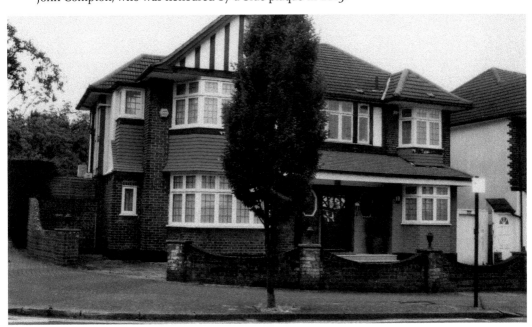

Around the Common

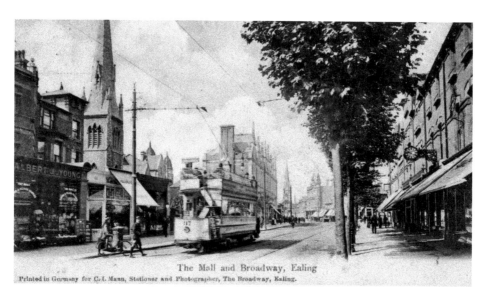

The Mall and Broadway, Ealing
Printed in Germany for C. I. Mann, Stationer and Photographer, The Broadway, Ealing.

Ealing Mall

This view of the Mall, which leads to the Common, is still a shopping parade, but the type of shops has changed dramatically. In 1905, those on the left included J. Hammett & Co., drapers (visible on the far left), a branch of Boots the chemist, and one of Long and Pocock's dairy stores, and on the right of the picture, G. H. Stoneman, watchmaker and jeweller (just visible below the clock sign), Samuel Spaull's booksellers and Francis Jackson, a church decorator. Although the protruding clock remains, a betting shop is underneath, and both sides of the road boast numerous bars, cafés and takeaway venues, though there is also a paint and wallpaper shop, and a bank. The church was the Wesleyan Methodist church, now a Polish Catholic church.

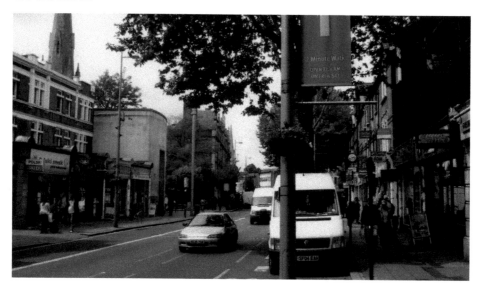

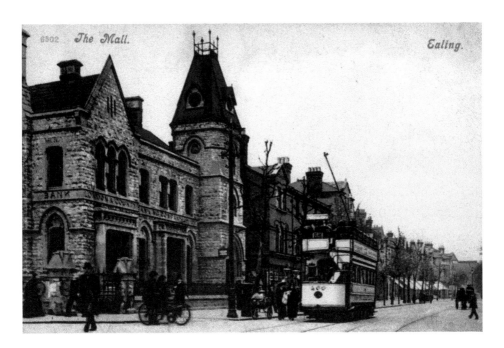

Old Council Offices

The building dominating both pictures was the offices of the Ealing Local Board from 1872 to 1888, built by Charles Jones in the same style that he built the Congregational church (*see page 43*), and the town hall (*see page 18*). However, the offices soon became too cramped for the increasing number of bureaucrats employed at the ratepayers' expense, and sharp-eyed readers will note the title 'London and County Bank' on the building, which owned it from 1889 to 1910. Since then it has changed its name – London County and Westminster Bank from 1901 to 1923, the Westminster Bank, 1923–70, and finally a branch of the Natwest Bank. The shops to the bank's immediate right were those of a surveyor of taxes and a solicitor's in 1905, but are now restaurants.

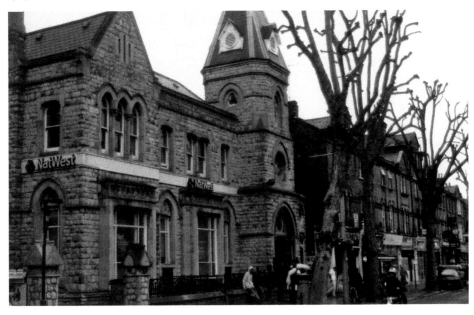

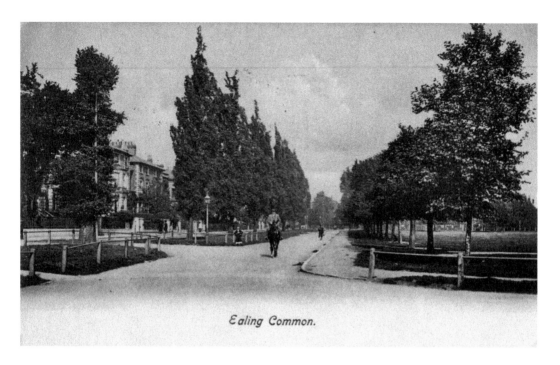

Ealing Common.

The Common

The western side of the street called The Common, certainly towards the northern end, boasts a number of large detached houses, built in the nineteenth century. About the time of the postcard, the residents here included Henry Green, first mayor of Ealing, and Walter Green, a dentist. One of the houses was used as a school for young ladies, and another as a private medical and surgical home. The rural aspect of Ealing was still apparent at this time, as evidenced by the gentleman on horseback, and perhaps the cyclist in the background. No such fears of motor cars are evident. Some of the white fencing survives, as do the houses and the pleasant ambience.

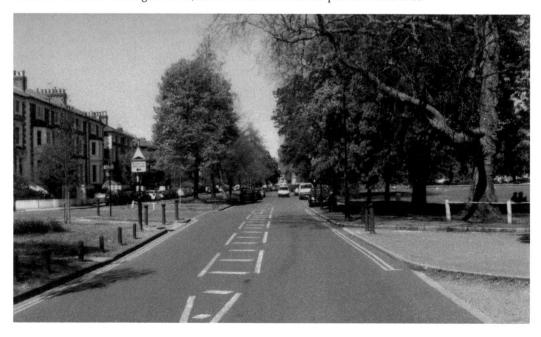

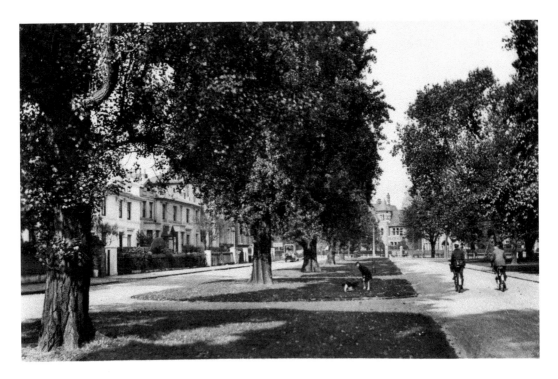

The Common (South End)

The same street, a little further south. This view of the houses built on the western side of Ealing Common in the first half of the nineteenth century has changed little over the years. Yet whereas at the beginning of the twentieth century almost all were lived in by a single family, by the 1960s most had been subdivided into flats. Some of the houses have had garages at the rear since the 1920s.

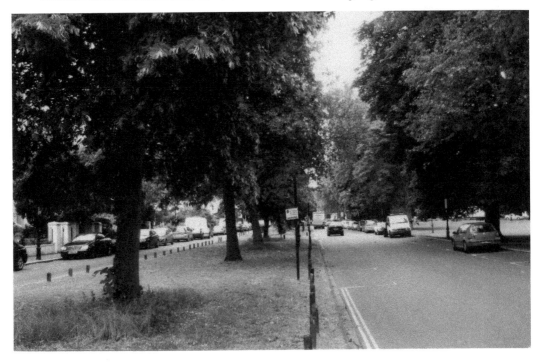

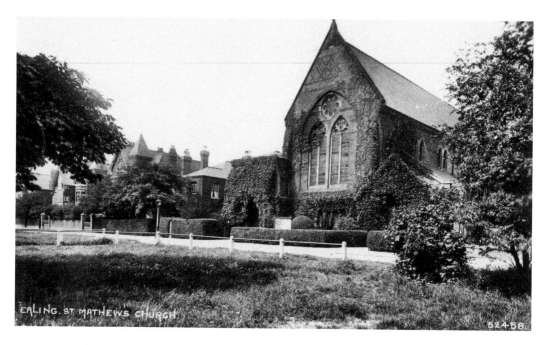

St Matthew's Church

St Matthew's church has not changed too much externally since it was built in 1884/85. The church was also used by Polish Catholics in Ealing, before they acquired their own church in Ealing in 1986, the former Wesleyan church on Windsor Road (*see page 38*). In 1900, Charles Jones wrote of the church, 'The exterior is plain, but the general outline is pleasing, and when completed will form a striking feature from Ealing Common and its surroundings.' The church was consecrated by the Bishop of London, and was built on land given by Edward Wood, owner of the Hanger Hill estate. On the left of the church is the vicarage, and in 2005 a plaque was placed to commemorate the former residence of England's greatest female tennis player, Dorothea Chambers, daughter of the vicar.

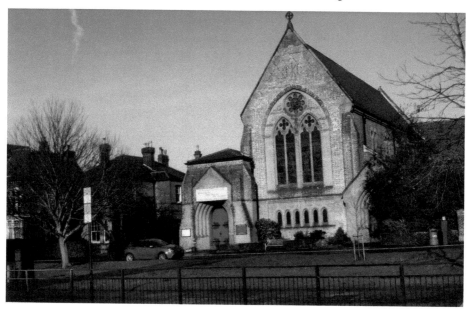

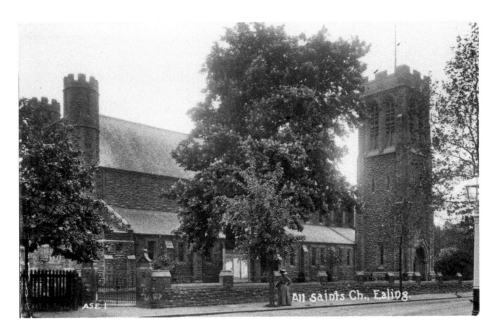

All Saints' Church

All Saints' church has the unique distinction in that it is dedicated to the memory of an assassinated Prime Minister – indeed it is known as 'The Spencer Perceval Memorial Church', consecrated on the dedicatee's birthday, 1 November (hence 'All Saints'), albeit in 1905. The architect was William Pite, who lived in a house in nearby Elm Grove Park. He also designed the Ealing almshouses in Church Gardens. One change is that in 2009, a green plaque was erected on the church tower on the bicentenary of Perceval being appointed Prime Minister. Another is that initially the church was merely a chapel of ease for St Mary's (*see page 39*), but was assigned as a parish church in its own right in 1948, and is now a joint parish with St Martin's, West Acton. Otherwise, very little has altered since these two pictures were taken. Fans of the 1970s sitcom *Terry and June* may remember that the hapless couple spend most of one episode trapped in the bell tower of this church.

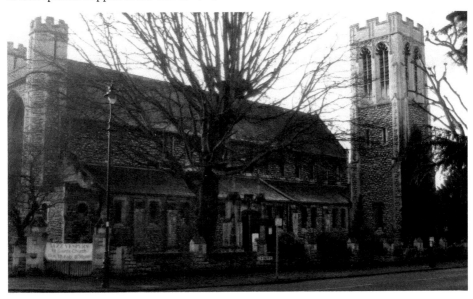

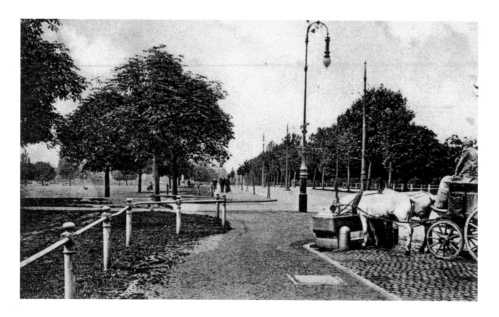

Water on the Common

These two views of Ealing Common and that part of the Uxbridge Road vary considerably. The Common was once part of the Bishop of London's land, but was administered by the Ecclesiastical Commissioners in the nineteenth century when they passed it to Ealing Council to manage. The still rural scene shows a horse drinking from the water trough, and a water fountain can be seen in the background. Both were the result of a scheme initiated by Miss Compton, secretary of the Ealing branch of the Society for the Prevention of Cruelty to Animals (as the RSPCA was once known). The press remarked, 'Miss Compton ... deserves the thanks of the public for her continuous and indefatigable exertions on behalf of the dumb and frequently ill-treated animals.' The cost was £180 and despite fundraising events, such as amateur dramatics, there was still insufficient money, so Ealing Council took over these and paid for their completion. The street lamp and white railings are also prominent. The modern picture shows that the water trough, long redundant, is gone, as are the white railings. Instead, less attractive railings and traffic lights indicate a potentially more dangerous environment, as does the increased traffic on the roads.

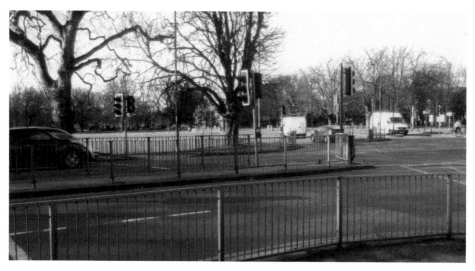

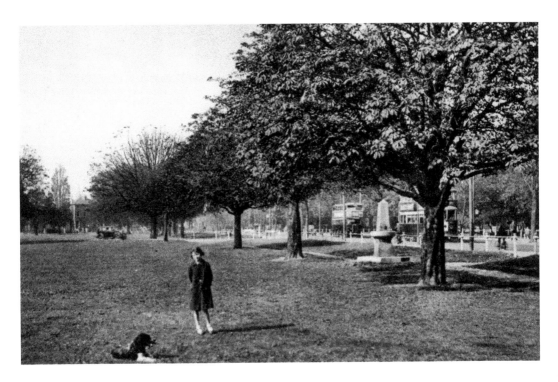

Ealing Common

Another charming photograph of the Common, though from the post-First World War era. The view more recently is less so. The water fountain still exists, but it can now only be seen surrounded by orange tape and looks forlorn (the water trough disappeared in the 1970s). The trees are no longer there, though younger ones have been planted in their place. The Uxbridge Road was once full of trams and buses, but although there are still buses, trams disappeared in 1936.

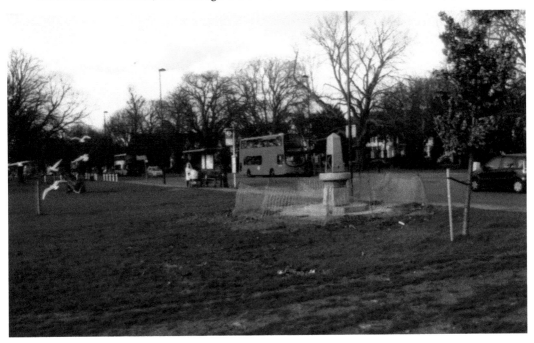

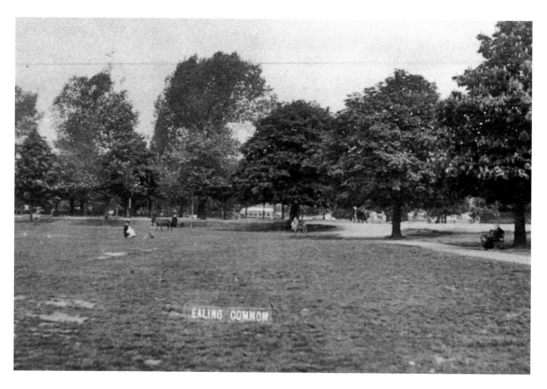

Centre of the Common

This view of Ealing Common has not changed essentially over the decades. There is the expanse of open space in the foreground, the chestnuts in the centre, and just about visible, public transport in the background, travelling along the Uxbridge Road. Ealing Common Society have done much to help preserve this important local amenity.

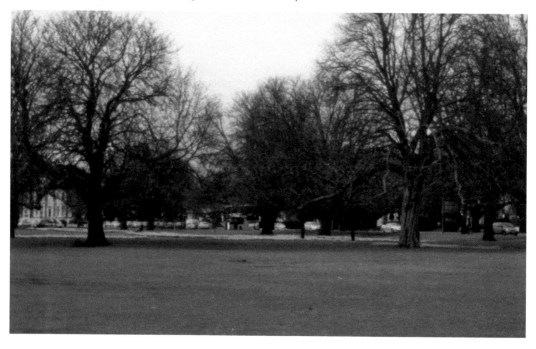

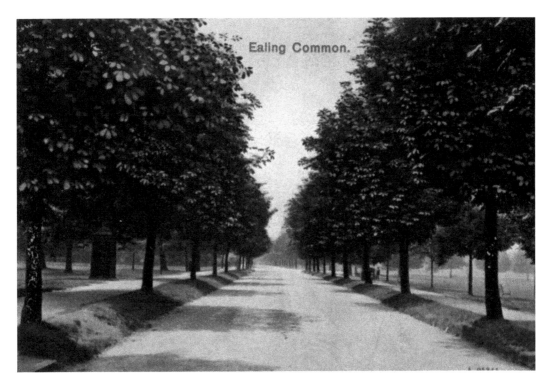

Ealing Common.

Telephone Box on the Common

Another view of the Common, taken opposite St Matthew's church (*see page 88*), and showing the public telephone box. This stood on the site from at least the early 1930s and until around the 1970s. It has been gone for some decades now.

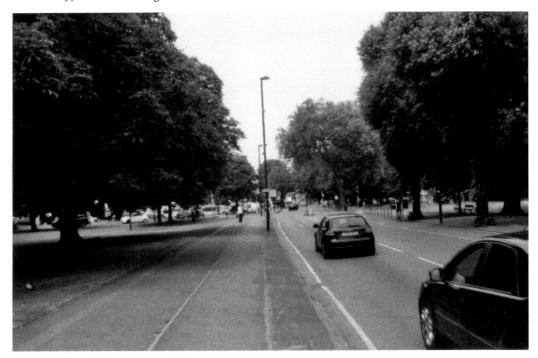

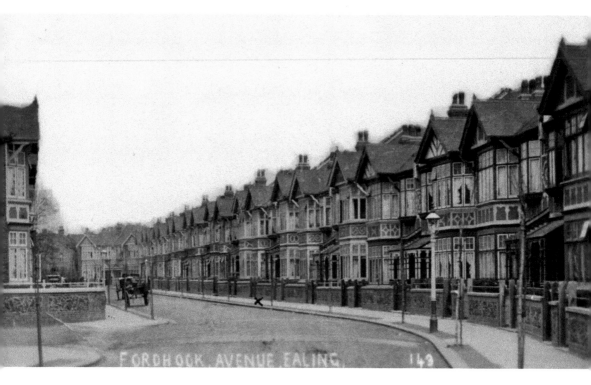

FORDHOOK AVENUE EALING. 143

Fordhook Avenue

Fordhook Avenue was built in 1904/05 by Blount and Kendal, builders of Kensal Rise, on the site of the grounds of an eighteenth-century house named Fordhook, demolished in 1903. Famous occupants included Henry Fielding, the novelist and magistrate, and Lady Noel Byron, widow of the famous poet. Save for the cars, there has been very little change in these scenes.

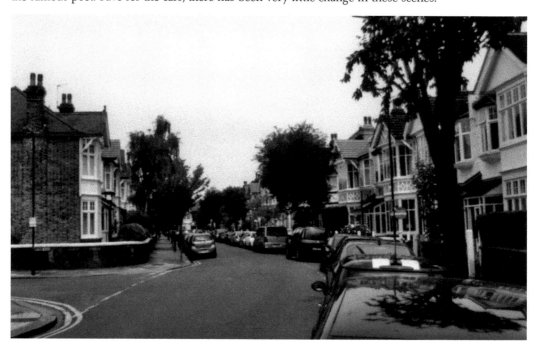

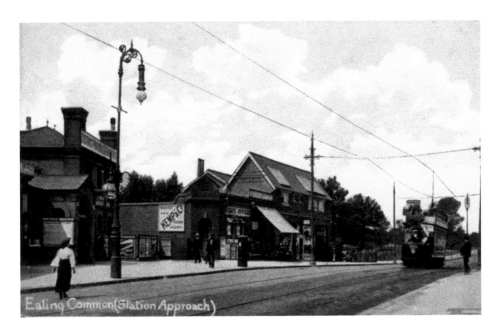

Ealing Common(Station Approach)

Ealing Common Station

The local newspaper reported in July 1879 that the opening of the Metropolitan District line from Turnham Green to Ealing Broadway was the most important development in Ealing since the opening of the GWR line in 1838, but complained that trains should run later in the evening for Ealing's returning theatre-goers. One of these stations was, of course, the Ealing Common station, as seen here. The parade of shops to the right of the station, on the aptly named Station Parade, included, in 1905, an estate agent's, a grocer's, an off-licence, a post office, a photographer's studio and a nurseryman. The Underground station was rebuilt in 1931 for the Piccadilly and District line to the bare concrete design of well-known Underground station architect Charles Holden (1875–1960). There is still an estate agent's next to the station, but the other shops now include a dry cleaner's and a computer shop. Holden also designed Northfields Underground station.

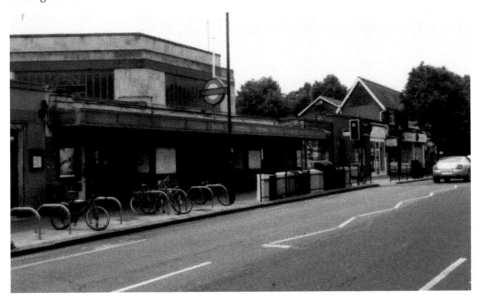

Around Hayes Through Time

Philip Sherwood & Hayes & Harlington Local History Society

This fascinating selection of photographs traces some of the many ways in which Hayes and the surrounding areas have changed and developed over the last century.

978 1 4456 1444 1

96 pages, full colour